IMAGES
of America

PARKER

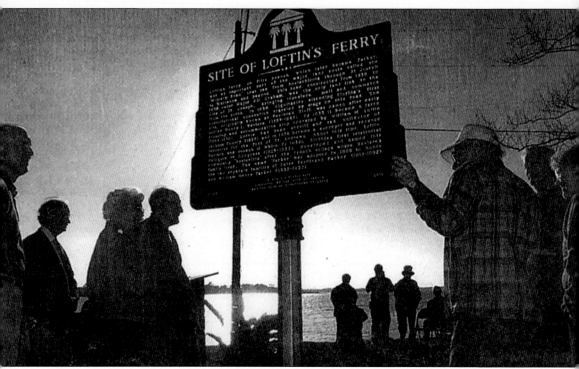

Parker residents gather for the dedication of a memorial marker in 2002 commemorating the location of William Loftin's ferry, established in 1836. Loftin's Ferry, on Pitts Avenue, which later became Parker, was an important part of the major land route called the "Military Road" that ran from Apalachicola through St. Joseph to Marianna and beyond. This road, constructed from 1836 to 1838 under Maj. J.D. Graham, was the only land link to the city of St Joseph, bringing travelers, mail, and commerce from the north. In 1838, dignitaries attending Florida's first constitutional convention traveled by stage on this road. The site, originally known as Riviere's Bluff, was named after early settler Henry L. Riviere (1785–1845). By 1835 it became a ferry crossing and accommodation stop operated by William M. Loftin (1785–1838). Loftin had been sheriff and tax collector of Jackson County (1823) and in 1836 became a surveyor and revenue inspector for the Port of St Andrews. About this time, Loftin, Riviere and Joseph M. White (d. 1839), Florida's first territorial delegate to Congress (1825–1837), developed and named this community "Austerlitz" after the French village where Riviere's family lived. The name "Parker" was adopted in 1886 to honor the two separate families of Peter Ferdinand Parker (1817–1892) and William Henry Parker (1857–1937). (BCPL.)

(*On the Cover*) This gathering was probably at the Union Church, or perhaps was a family picnic for Pratts, Parkers, and other kinfolk. The photograph was taken in January or February 1910. From left to right are (front row) Stuart Pratt, unidentified, Rosa Pitts, Vera Pratt, three unidentified, and Harvey Pratt; (back row) two unidentified, Charles Parker, Jessie Parker, Arthur L. Pratt, Gertrude Parker Pratt, two unidentified, Willie Parker Pratt, and Illinois (Elley) Mashburn Parker. Elley's sons Paul and Earl Parker stand in front of her. (AC.)

IMAGES
of America

PARKER

Ann Pratt Houpt

ARCADIA

Published by Arcadia Publishing,
an imprint of Tempus Publishing, Inc.
2 Cumberland Street
Charleston, SC 29401

Printed in Great Britain.

Library of Congress Catalog Card Number: 2003103939

For all general information contact Arcadia Publishing at:
Telephone 843-853-2070
Fax 843-853-0044
E-Mail sales@arcadiapublishing.com

For customer service and orders:
Toll-Free 1-888-313-2665

Visit us on the internet at http://www.arcadiapublishing.com

For the Grandparents.
I wish I'd listened better.

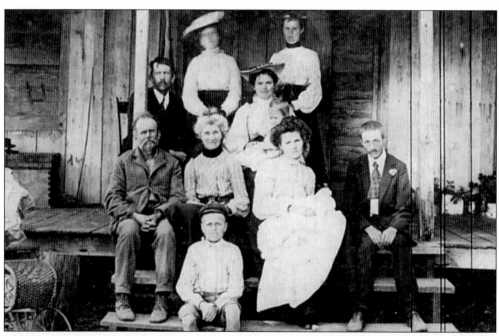

This is a family group of Pratts and Parkers. Seated in front is John Parker. In the second row from left to right are John William Parker, his wife Nancy Amanda (Folks), their daughter Mattie and her husband, Audley Spicer. In the third row are Arthur L. Pratt and his wife Gertrude (Parker), holding one of their children. Her father, John, died March 30, 1908, so this picture may be from c. 1903. The baby Stuart was born on Dec 19, 1902. In the fourth row are Willie Pratt and Annie Tipton Mashburn. (AM.)

CONTENTS

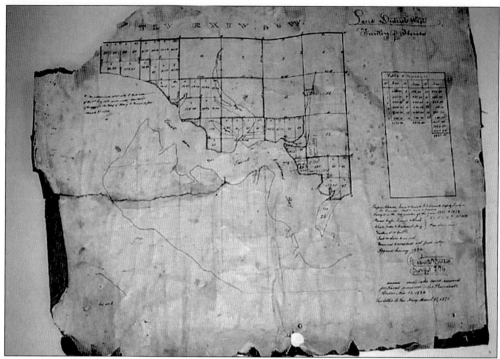

This 1834 map of Land District West, Territory of Florida, shows the area around Parker.

ACKNOWLEDGMENTS

This book has been in the making ever since our great-grandparents gathered their children to have their pictures taken. Some handed down leather-covered albums, crumbling now, or old boxes of snapshots, as well as the professional photographers' photographs and postcards. I feel blessed that Parker pioneers left so many images. I started with the collection of my grandparents, Arthur L. and Gertrude Parker Pratt. Then Florence Parker Gilbert gave me access to the albums of her sister Edwina Parker Sweeney, who had completed the story of her life as a teacher and school principal shortly before her death last year. These provide a wonderful record of school life in Parker.

Evelyn Davis Roberts provided the albums of her mother, Leah Davis, and of Dr. and Mrs. W.P. Parker as well as the more recent photographs of her late husband Roy Roberts, who served as Parker's fire chief.

Joyce Robertson (retired city clerk), Thelma Pratt, Edith Parker Clark, Crook Stewart, Margaret Childers Ellsworth, Elmer Kenneth Parker, Arthur Mashburn, and Mary Frances Miller Shores all contributed valuable historical images. Betty Robbins Norem is thanked for her family photographs and for the census and cemetery index she provided.

Special thanks to Laura Ruth Pennington Grace for her untiring work gathering photographs, scanning them, and delivering them to me with the identifications. As she said at one point, "We waited too long to do this. The old ones are all passed away." Thanks to Mayor Brenda Hendricks for her support.

Finally, I thank Rebecca Saunders and the technical services staff at Bay County Public Library for valuable assistance with printing photos and other computer help and support.

INTRODUCTION

Parker has always been a tourist attraction, according to one pioneer descendant. Florence Parker Gilbert says folks from Marianna and Dothan and other communities up the country used to come on vacation and had summer cottages around the bay, for as long as she can remember.

It's certain that Native Americans knew about the plentiful oysters, scallops, crabs, shrimp, and fish in the bay and gulf many years before white settlers arrived here. The community developed as families of fishermen/farmers settled near the shores so they could use sailing vessels to get around. Inland, roads were few and far between.

William Loftin was a surveyor who came here after the War of 1812. He participated in the government of the Florida Territory, and began to plan a city near the present city of Parker, hoping for it to become the capital of the territory. Austerlitz failed, as St. Joseph was instead named as such.

In 1836–1838 Loftin established a ferry at Riviere's Bluff in what is now Parker. Crossing the east arm of St. Andrews Bay to the peninsula, it connected the only land route to St. Joseph, the territorial capital. For some time this area was known as Loftin's Fish Camp. Loftin was prominent in local government. He died in 1845 and was buried in the cemetery he had donated to the community.

Around 1827 in Danzig, Germany, a youngster made plans to leave the country. He came by ship to the coast of northwest Florida. He said he was born January 1, 1817, and his name was Peter Ferdinand, but didn't give a surname. Some folks named Parker adopted him and he took their name. Peter Ferdinand Parker became a fisherman, grew up, and married Loftin's daughter Ann. Peter and Ann prospered, carrying on extensive trade with farming communities to the north, sending barrels of salt fish by covered wagon as far away as Dothan, Alabama, and bringing back corn, corn meal, and potatoes.

After the Civil War, land speculators in the North (such as the Cincinnati Land Company) influenced many people to come here, and among those who came to Austerlitz was the family of Dr. W.P. Parker (no relation to Peter Parker). On the strength of the two Parker families and a postal inspector (who legend has it was also named Parker), a post office was established, and the name of the community was changed from Austerlitz to Parker c. 1887. Dr. Parker's son, W.H., and wife Ethlyn managed the post office for many years.

The construction of a paper mill by Southern Kraft Corporation to the west of Parker in 1930–1931, and the establishment of Tyndall Field at the time of the World War II, brought new housing, larger schools, several churches, and general prosperity.

In the late 1940s the Parker Men's Club, our first civic organization, was formed and worked for the naming of streets and formed the first group of volunteer firefighters, with Roy Roberts as chief. The club built a community center with the help of volunteer firemen, worked at the completion of a Little League ball park, and was instrumental in incorporating the City of Parker. The charter was granted July 7, 1967, and officials were elected on September 12. Earl Gilbert was the first mayor and the four councilmen were Aubrey Dykes Sr., Jack Askew, Irving

Myers, and Cliff Fleming Sr. Joyce Robertson was hired as city clerk and Joseph B. Walker was chief of police.

In 1974, when Stuart A. Pratt prepared a brief history of Parker for the Men's Club, the city had installed a central water system with federal assistance and was planning sewage disposal. Revenue sharing had helped install street lights and paved streets and at that time "the city operated within its income." Earl Gilbert was serving his fourth term as mayor and Jack Askew was head of the water department.

In 2003, the city's second mayor, Brenda Hendricks, heads a prosperous little city that has five parks and a busy staff of city workers. Council members include E.B. Reese, Ed Pogue, Will Dost, and Tonya Barrow. The police chief is Charles Sweatt, the city clerk is Lois LaSeur, and the fire chief is Andrew Kelly. Winn-Dixie, the community's first supermarket, is still in business. The city has two banks, the Tyndall Federal Credit Union and a branch of Bay Bank. There are restaurants, car repair centers, a bowling alley, and a skating rink. The small post office begun by W.H. and Ethlyn Parker, and continued for years by Rosa Pitts Pennington, has developed into an East Side branch serving Parker and Callaway efficiently, but not as "cozily" as Ethlyn and Rosa did.

KEY TO PHOTOGRAPH COURTESY ABBREVIATIONS

AWA: Annice Woodham Anderson
AC: Author's collection
BCPL: Bay County Public Library
EPC: Edith Parker Clark
FPG: Florence Parker Gilbert
LRPG: Laura Ruth Pennington Grace
MBH: Mayor Brenda Hendricks
AM: Arthur Mashburn
BRN: Betty Robbins Norem

EKP: Elmer Kenneth Parker
EDR: Evelyn Davis Roberts
JR: Joyce Robertson
RS: Ron Sarvis
MFMS: Mary Frances Miller Shores
CS: Crook Stewart
BBBC: Bible Believers Baptist Church
FBCP: First Baptist Church of Parker
PUMC: Parker United Methodist Church

The Martin House, on the bluff above Martin Bayou, is still standing today. But the bayou is now Martin Lake, and the house and property are owned by the paper company (now Smurfit–Stone). The house is sometimes used for civic meetings and other gatherings as well as paper company functions. The bayou is fed by fresh water springs and a dam was erected years ago, with a spillway that allowed the water to become fresh over time. (EDR.)

One
EARLY SETTLERS

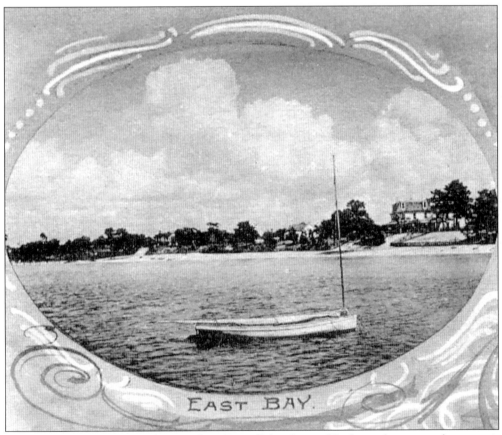

EAST BAY.

This boat on the east arm of St. Andrew Bay off the shore of Parker is from an early souvenir book of St. Andrew given "To Stuart A. Pratt from Grandma." (AC.)

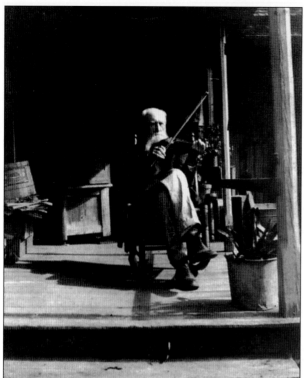

Dr. W.P. Parker, one of the founders of Parker, is shown here playing his violin c. 1914. (EDR.)

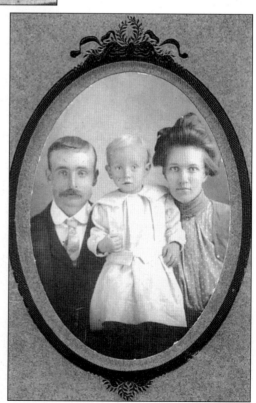

This a portrait depicting Charles Monroe Mashburn, his wife, Eliza Folks Mashburn, and their son, Charles Arthur Mashburn. (AM.)

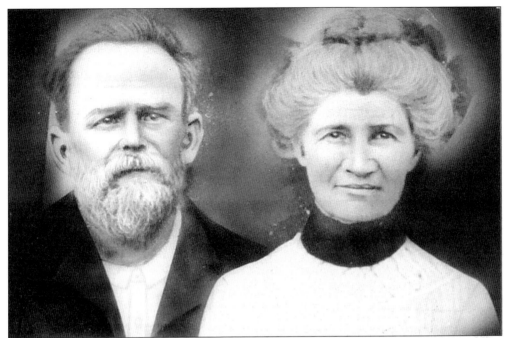

John William Parker was born in 1849 to Peter Ferdinand and Annie Loftin Parker. He was a fisherman and farmer. He married Nancy Amanda Folks (1851–1916) on Aug 15, 1870. They had the following 11 children: Osgood Cook, Lola Virginia, James Walter, William Daniel, Gertrude, Willie Ophelia, Mattie, John Thomas, Charles Wesley, Robert Cleveland, and George. (EKP.)

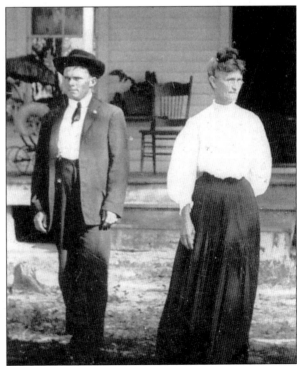

Charles M. Mashburn and his wife Eliza Folks are seen in front of their house. Eliza and Nancy Amanda Parker were sisters. (AM.)

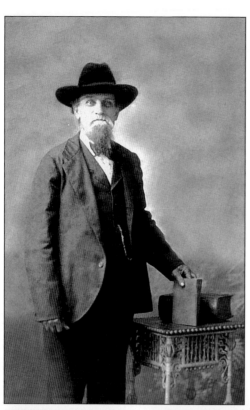

This is pioneer settler Noah Pitts. He helped construct the first lodge building. (LRPG.)

Sara Rebecca Parker (1871–1923) was the second daughter of Charles T. Parker (older brother of John William). She married Noah Pitts. They had a home on Pitts Bayou. (LRPG.)

Dora Lee Parker (1867–1934), Sara's sister, married William Alonzo Weeks. Their children were Oscar Macune, Sarah Lee, Alonzo Polk, Charles Bordeu, Annie Rebecca, Ruby Cordelia, Peter Bartemus, and Eva Mae. (LRPG.)

In this photograph Lenora Pitts stands between her mother, Rebecca Parker Pitts (1871–1923), left, and her grandmother, Sarah Parker (1849–1930). Lenora was born April 1, 1910. (LRPG.)

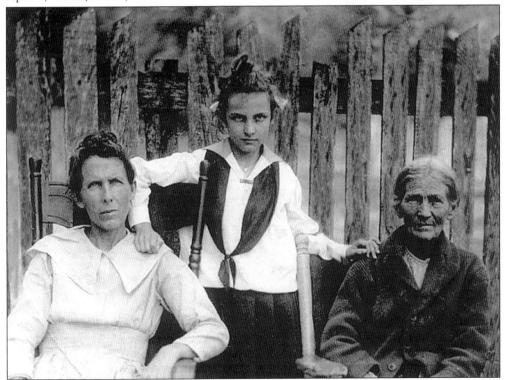

13

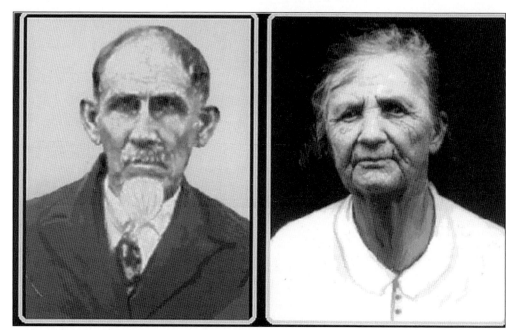

Martin Davis, born March 12, 1850 in Calhoun County, Florida, married Lovey Syrena Cooper, born December 25, 1853 in Donaldsonville, Georgia. In 1887 Martin Davis homesteaded 160 acres of land between Parker Bayou and present-day Highway 98, when Parker was in Washington County. Martin died December 29, 1930 and Lovey died June 26, 1936. They are buried beside each other in the Parker Cemetery. (BRN.)

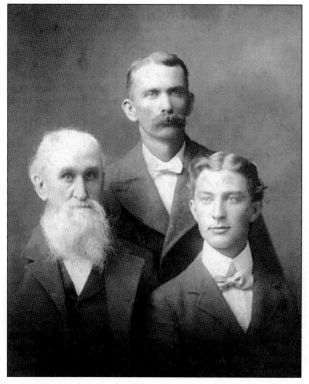

This portrait is of Dr. W.P. Parker, left; his son, W.H. Parker, center; and grandson J.W. Parker, right. (EDR.)

Two

FRAMED BY THE BAY

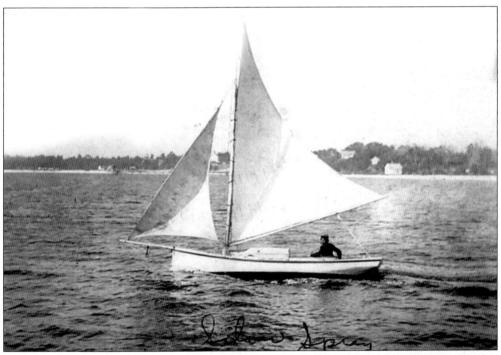

Arthur L. Pratt, in his sailboat the *Silver Spray*, is shown on East Bay with the shores of Parker in the background. This trip could have been business or pleasure. He loved to race, and got together with others to form the St. Andrew Bay Yacht Club. The *Silver Spray* was said to be the fastest boat on the bay in 1907, and won the cup in a free-for-all race. He did not stay active in the yacht club's organization, but he had the contract to maintain the fish-class boats for the club. (AC.)

This is the first Parker Lodge building, constructed in 1892 by W.H. Parker. Meetings were held the first Saturday on or before the first full moon. (EDR.)

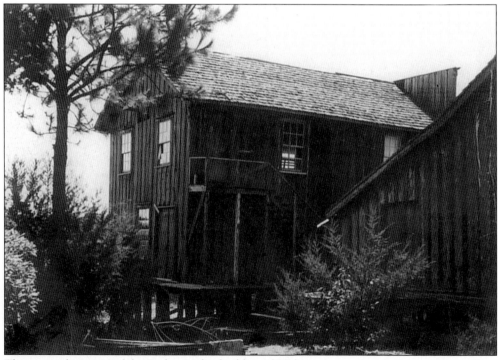

This is another view of the Parker Lodge building. (CS.)

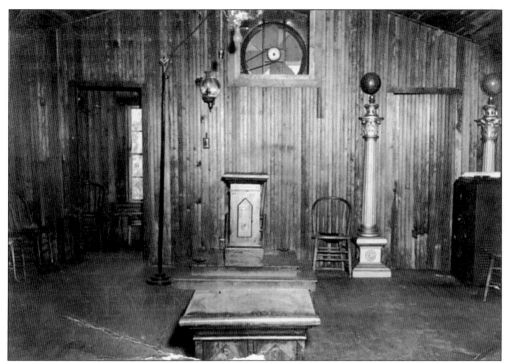

This is a view of the Eastern Star Lodge inside the Parker Lodge Building. Note the fan in the wall. (Courtesy Thelma Pratt.)

This is Noah and Rebecca Pitts's home place on Pitts Bayou. They had three daughters: Rosa, Jessie, and Lenora. (LRPG.)

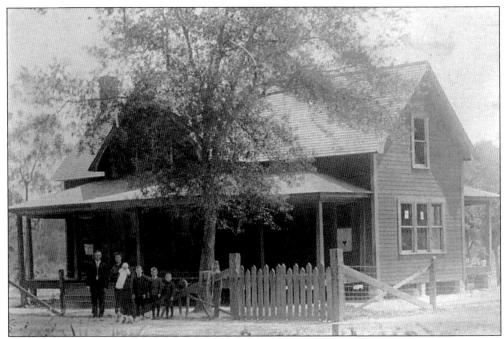

The Charles Mashburn home, shown here soon after construction of the house was completed in 1918, still stands on north West Street near Martin Lake. In front of the house is the family, (from left to right) Charles, Annie, Lona, Cliff, Harry, and Buford. (AM.)

Houses around the bay are nestled among trees, and are sometimes hard to see. But you could tell where the homes were by the docks extending into the bay. It is not known who owned this house. Bill Spicer, a net fisherman who celebrated his 90th birthday in 2003, said he might be able to identify it "if he could see the color of the roof." (AM.)

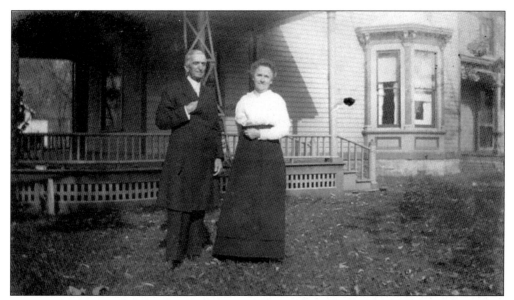

W.H. and Ethlyn Parker stand in front of their home. They ran the Parker post office (in the lodge building) for many years. (EDR.)

This is a picture of the W.H. Parker home as seen from the water. (EDR.)

Mr. and Mrs. A.L. Pratt are seen in front of their home on the bay. Arthur bought the house unfinished and got it ready for his bride, Gertrude Parker, a granddaughter of Peter Ferdinand Parker and Annie Loftin. They moved into the house in 1901 and lived there until their deaths—Arthur's in 1959, and Gertrude's in 1961. (AC.)

This is a view of Pratt Point in the early days, out in front of the house. Hurricanes over the years have eaten away at the bluff . (AC.)

Three
FAMILIES

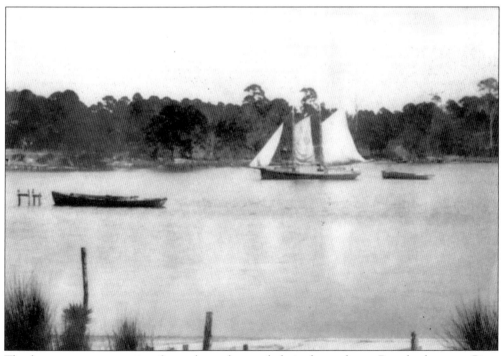

The bay was transportation for early settlers and their descendants. But the bayous—Pitts, Parker, Pratt and Martin—were havens for safe anchorage. This view is of boats on Parker Bayou. Parker Bayou was sometimes called East Cove, and Pratt Bayou was sometimes called West Cove. (EDR.)

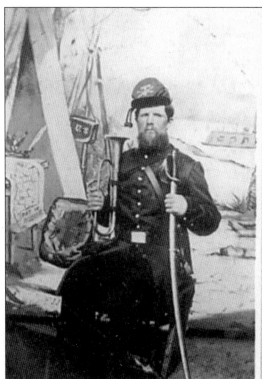

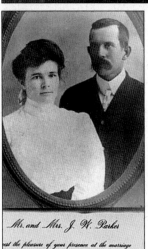

Ellen Pratt came to the area from Minnesota with her husband Lucius H. Pratt c. 1890. They brought all their children except their eldest daughter Carrie, who married and stayed in Minnesota. Their four sons were Willard, Ed, Arthur, and Lou, and their daughters are Belle, Lillian, and Hattie. Lucius H. Pratt is shown in his Civil War uniform when he served in the Second Minnesota Light Artillery. After the war he and Ellen owned a prosperous farm in Minnesota. (Author's collection.)

To the left is the original invitation Mr. and Mrs. J.W. Parker sent for the wedding of their daughter Gertrude to Arthur L. Pratt. (AC.)

Willie Ophelia Parker married Edmund S. Pratt April 2, 1905. They had two sons, Harold and Huell, and a daughter, Catherine. (Courtesy of Catherine Woodham.)

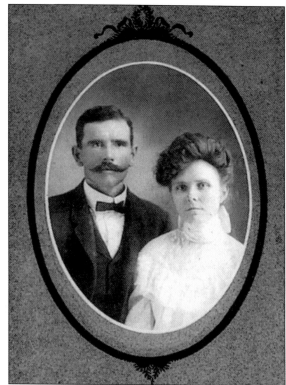

This is Willard Pratt and his family and "Jenny's brother and his family," according to a note on the photograph. From left to right are (front row) Ellison, Jeannie, and unidentified; (back row) Lillian, Willard, Lester, Clyde, and unidentified. (AC.)

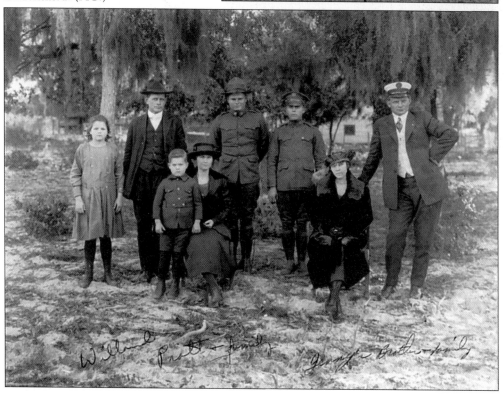

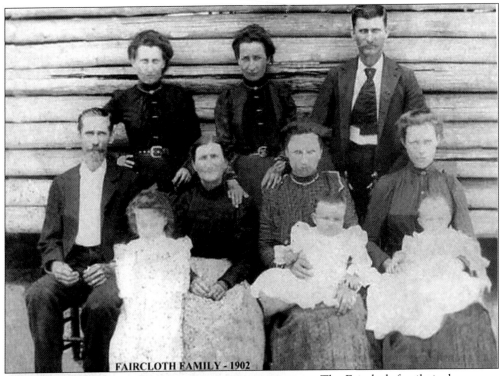

FAIRCLOTH FAMILY - 1902

The Faircloth family is shown here in 1902. In the front row from left to right are Emerson, Sarah, Janie, and Mary; in the back row are Betty, Danie, and Ben Faircloth. The baby at right is Ethelyn May Faircloth. (BRN.)

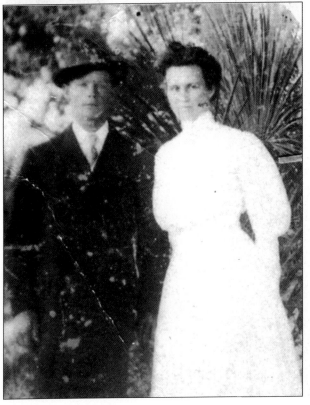

Charles Arthur Mashburn and Annie Rebecca Tipton are pictured on the day of their marriage, May 15, 1908. (AM.)

John Thomas Parker and Bertha Mary Hoskins are pictured on the day of their wedding, March 17, 1911. They had four children: Ellen, Lester, Lusty, and Elmer Kenneth. (EKP.)

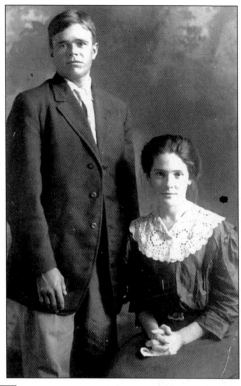

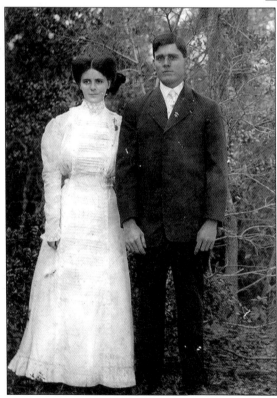

Charles Wesley Parker and Jessie Holmes Hinson are shown on their wedding day July 4, 1909. (FPG.)

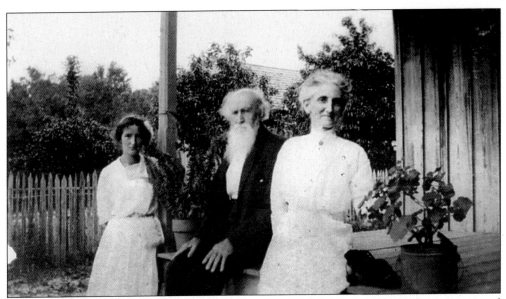

Leah Goins is pictured with her adoptive parents, Dr. W.P. Parker and his wife Emma around 1913. (EDR)

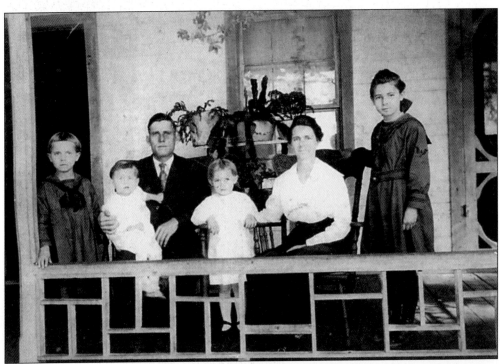

Charles Wesley Parker and his wife Jessie Hinson Parker and four of their children are pictured above c. 1920. Their children are, from left to right, Virginia, Charles, Florence, and Edwina. (EPG)

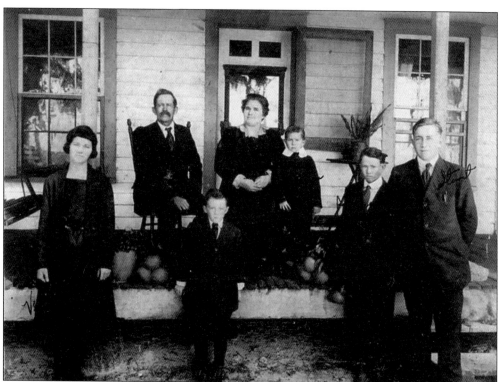

This Pratt family photo includes (front, left to right) Vera, Donald, Harvey, and Stuart; on the porch are Arthur L., Gertrude, and Angus. Note grapefruit on porch, and chicken wire around the bottom of the porch to keep varmints out from under the house c. 1918. (AC.)

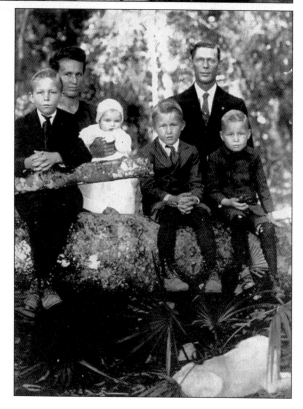

Charles Arthur Mashburn is seen with his wife Annie Rebecca Tipton Mashburn with their children (left to right) Cliff, Lona, Harry, and Buford, c. 1916. (AM.)

Mr. and Mrs. Hoskins are pictured above. On the back of the snapshot reads "this is the way they have always lived ever since I can remember–just like two kids today always full of love for each other." (Edith Parker Clark)

This photo of the Hoskins sisters was taken June 1, 1907. Bertha, left, was 13 and Addie was 16. Both later married Parker brothers, John and Walter. (EPC)

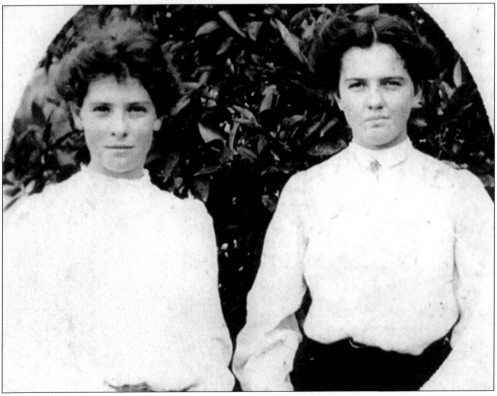

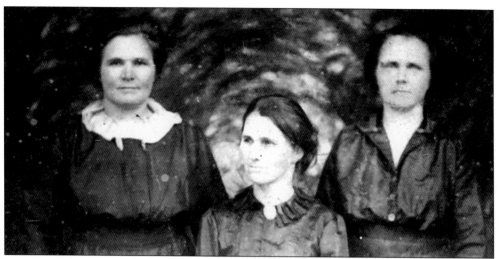

Three daughters of John and Nancy Amanda Parker are shown here. From left to right are Gertrude Pratt, Mattie Spicer, and Willie Pratt. (Courtesy of Thelma Pratt.)

Peter Ferdinand Parker III, son of Peter Ferdinand and Betty Graves, was born January 28, 1869. He married Illinois Mashburn in 1897 and they had three children, Earl Clarence, Enda Luvenia, and Paul Jones. Illinois died in 1912, and Peter married Mattie Renald Davis, and they had the following four children: Ernest Mitchell, Winifred, Mary Frances, and Doris Jean. The family also included Mattie's children Lucy, Corinne and Tom Davis. (LRPG.)

Vera Pratt and Charles Raffield are shown here shortly before their marriage. They were wed on August 16, 1925. (Courtesy of John C. Raffield.)

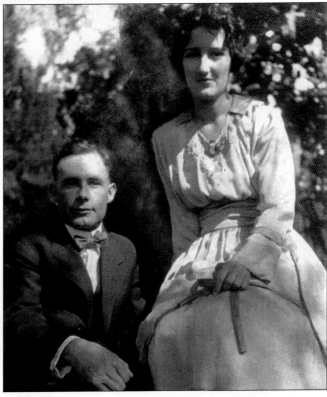

Martin Davis and Leah Goins are pictured here on their wedding day, February 16, 1919. (EDR.)

This postcard shows Columbus and Iva Holley, who made their home in Parker (now on 11th Street). They were members of Parker Methodist Church and had three children, Charles, Raymond, and Fannie.

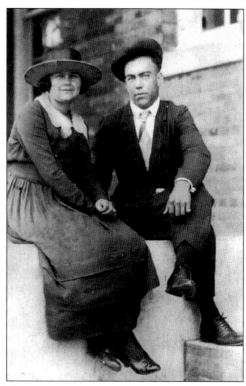

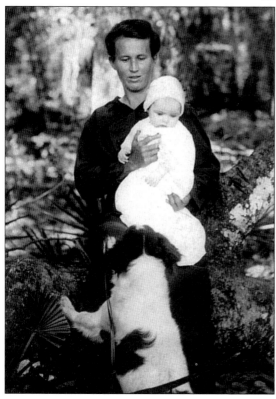

Annie Rebecca Mashburn is holding baby Lona and warning the dog not to jump up. (LRPG.)

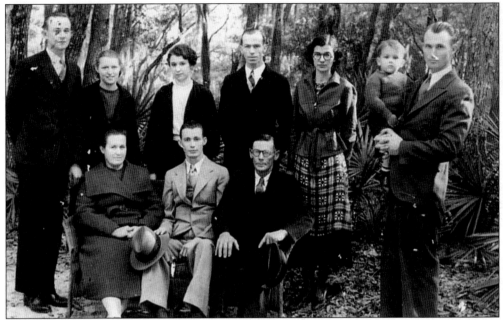

Three generations of Mashburns gather for a photograph c. 1936. They are, from left to right, (front row) Annie R. Tipton Mashburn, Buford Mashburn, Charles Arthur Mashburn, and Harry Mashburn (holding Arthur); (back row) Fred Maxwell, Lona Mashburn Maxwell, Ruby Lowery Mashburn, Cliff Mashburn, and Pauline McGill Mashburn.(AM)

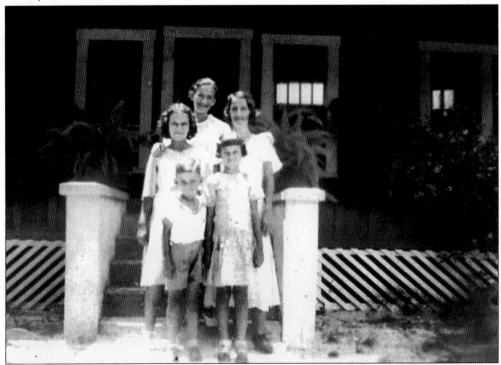

Mrs. Leah Davis and her children are shown in front of her house. In the front are Bud and Marjorie; in the back row are Evelyn, Florence, and Leah.

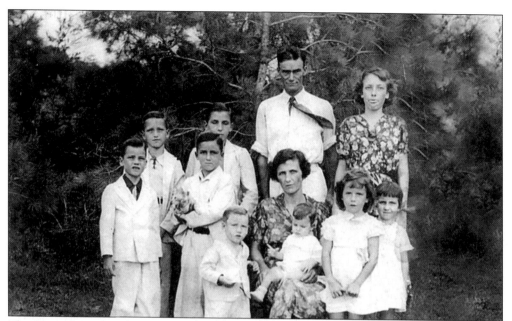

The Pennington Family gathered on the beach in front of their home for this portrait. In the front row from left to right are Horton, Rosa (holding baby Donna), Rosemary, and Laura Ruth; in the second row are Whit and Billy (holding Scrappy the cat); and in the back row are Gordon, Henry Douglas, Henry, and Argie. (Courtesy of LRPG.)

Gertrude Pratt is smiling as if her husband Arthur has said something very funny. In this view the pioneer couple relax in their yard where they had made their home for more than 50 years. (AC.)

On March 27, 1943 Miss Mary Marback and Lt. Elmer Kenneth Parker were married in the chapel at Fort Benning, Georgia. Here they are shown on their 50th wedding anniversary in 1993. On March 27, 2003 they celebrated their 60th anniversary at their home in Parker. (EKP.)

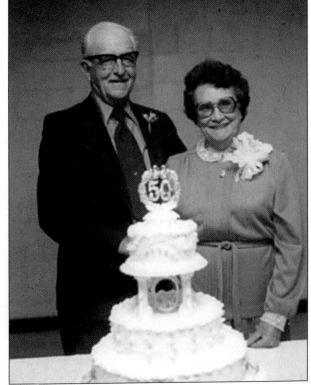

J.O. and Ruby Wilson celebrate their 50th wedding anniversary November 9, 1980. They came to Parker in 1941 when J.O. worked in construction at the new Tyndall Field. The Wilsons raised seven children: Jackie, Billy, Harlan, Miriam, Virginia, Dennis, and Mike. (Jackie Swearingen)

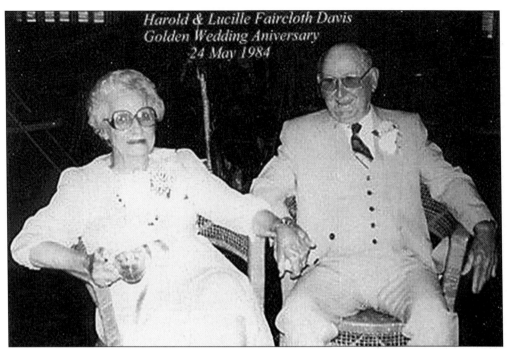

Harold and Lucille Faircloth Davis celebrated their 50th wedding anniversary on May 24, 1984.

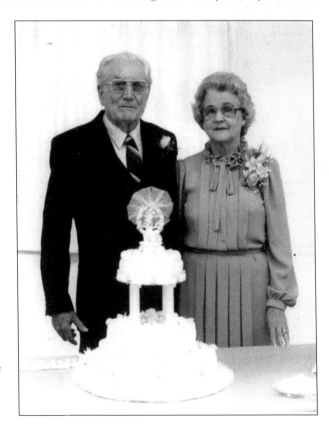

Stuart and Bernice Pratt celebrate their 50th anniversary November 16, 1983 at Parker Methodist Church. (AC.)

Ethelyn Mae Faircloth Robbins is shown at left about 1918. At right is Harlie Lee Robbins about 1920. She was born in Donaldsonville, Georgia in 1901, and he was born in Opp, Covington County, Alabama in 1895. (BRN.)

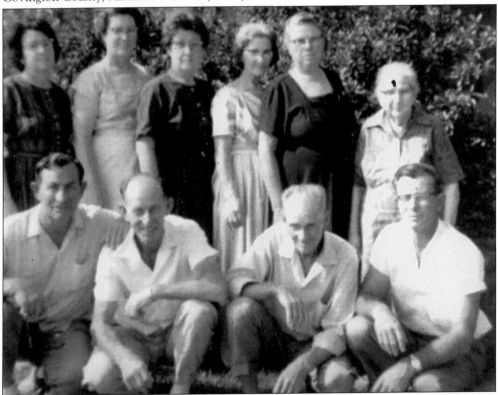

In this gathering of the Harrelson family are left to right (front row) Trilby, Albert, Harlie, and Oresta; (standing) Amy, Tina, Minnie C. Lena Belle, Jessie, and Lula. (BRN.)

Marvelle (Robbins) and Alva Gore celebrate an anniversary. They had four children, Tommy, Kenny, Andy, and Mary. (BRN.)

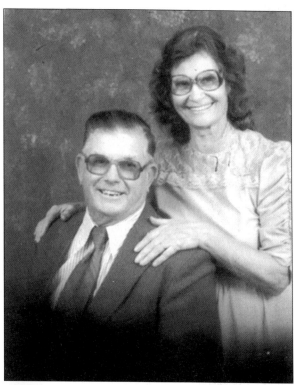

Peggy Sue Parker and Ronald Franklin Sarvis were married on February 6, 1954. They had a son, Ronald Jerome. (Courtesy of Peggy McDonough.)

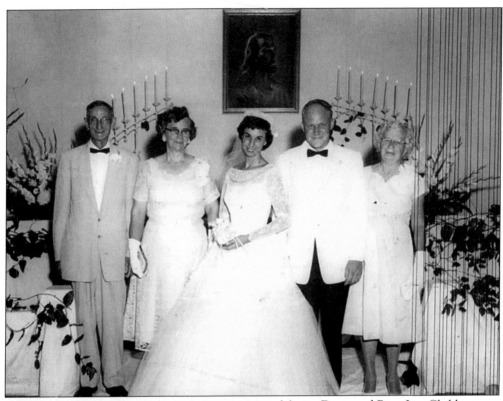

Martin Davis and Rosa Lee Childers were married in the Parker Methodist Church August 10, 1958. The wedding party (from left to right) are Willie and Mattie Childers, Rosa Lee, Martin, and Mrs. Mary Davis. Their children are Marty and Pamela, and granddaughter Amy. (Courtesy of Margaret Ellsworth.)

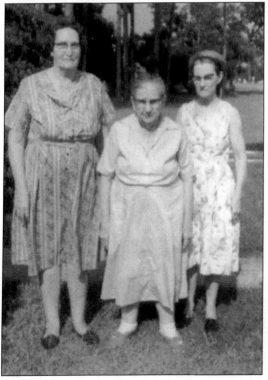

Pictured here from left to right are Ethie Robbins, Lula Harrelson, and Lena Belle (Harrelson) Creamer. (BRN)

Four
CHILDREN SHOULD BE SEEN . . .

Stuart Pratt wrote on the back of this picture, "just the two of us." He told his children that when he was a boy everybody wanted a skiff built by Dan and Robert Parker (his uncles). (AC.)

James Walter Parker, son of John and Nancy Amanda Parker, married Addie Hoskins and they had five children, Alice Estelle, Beulah Elizabeth, Edward Geddes, Marion William, and Edith Ruth. (AM.)

In this photograph of Walter and Addie Parker's children, little Edith (front center) is brushing her hair. Behind her (from left to right) are Ed, Alice, Beulah, and Marion. (AM.)

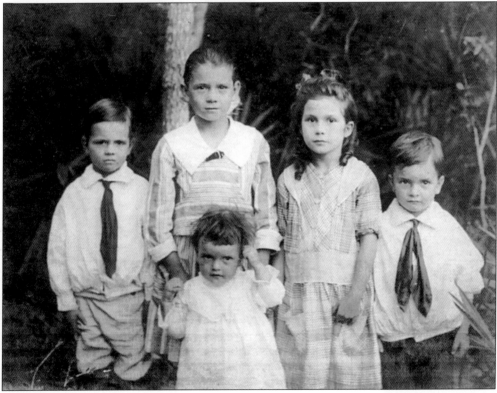

Vera Pratt, daughter of Arthur and Gertrude, sits outdoors in a child-size rocking chair looking very serious. She was born on April 19, 1906. (AC.)

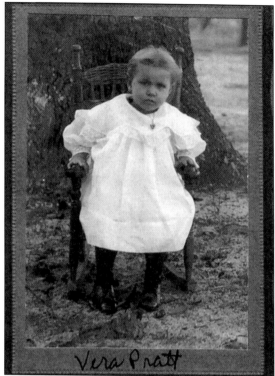

Vera Pratt

Mrs. W.P. Parker is pictured with a group of mothers and children. She is second from left in the second row of ladies. Mary Wilson Davis is at far right in that row. Maybe it was a patriotic holiday. (Note the flag-waver.) (EDR.)

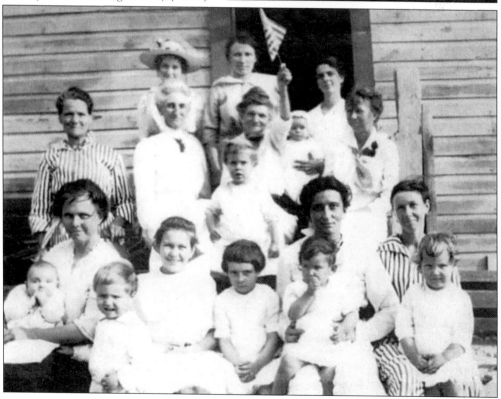

This picture shows four of the six children of Osgood Parker and Addie Bowen, who married June 26, 1899. The children are Osgood Carl (age 11), Jeannette (age 7), Eunice (age 5), and Cecil Marion (age 2). Bessie Bowen and Philip Albert are not shown. (AM.)

As young as they are, these babies seem to already know that being photographed is serious. The identities of the two children on the right are unknown; at the top left is Stuart Pratt, and at the bottom left is one of John and Bertha Parker's babies. The bottom right is labeled Emma and is in the Leah Davis collection. (Top right AM; top left AC; bottom left EPC; bottom right EDR.)

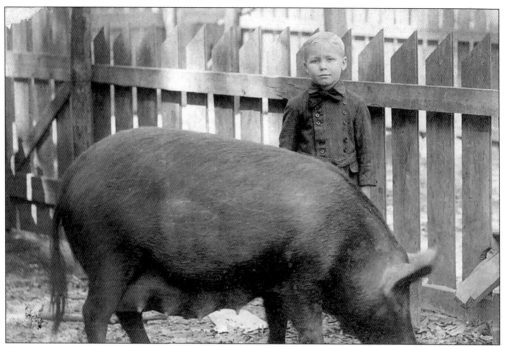

This photograph of Buford Mashburn—with a very large pig—was printed as a postcard c. 1918. (AM.)

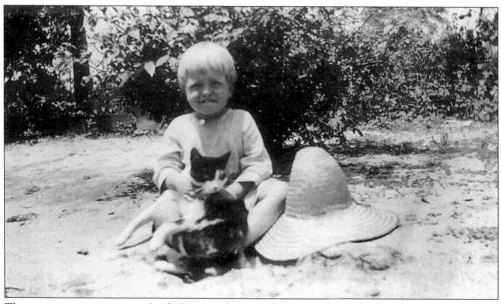

This youngster was among Leah Davis's photographs. It is not really clear whether the cat is being petted or squeezed tightly. (EDR.)

Catherine Pratt, photographed in her Aunt Gertrude's yard on the Fourth of July, seems to be draped in some sort of flag, c. 1921. (AWA.)

These two playmates seem to be looking for adventure. One is carrying a paddle. (AC.)

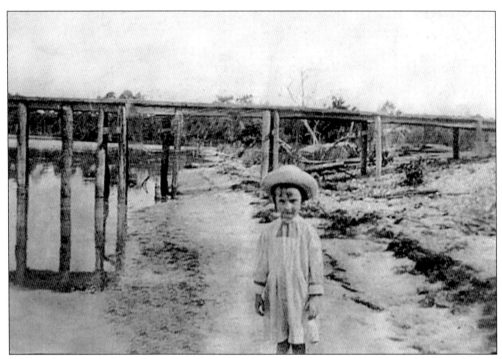

In this photograph, Lenora Pitts stands on the shore of Pitts Bayou. The Pitts's dock is in the background. Lenora was born April 1, 1910. (LRPG.)

Betty Lou Robbins, daughter of Harlie and Ethie Robbins, is shown at age eight. (BRN.)

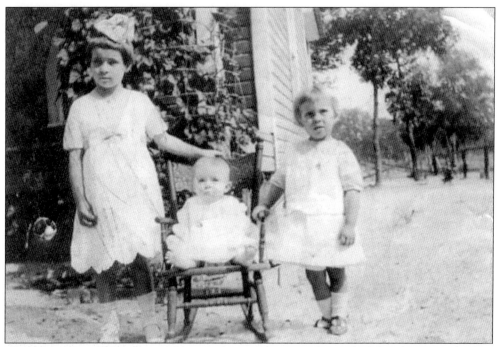

Three daughters of Charles and Jessie Parker are shown in the yard of their home on the bay, *c.* 1917. From left are Mary Edwina, Florence Esther, and Jessie Virginia. (FPG.)

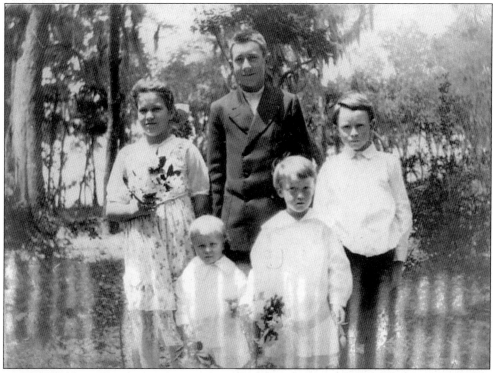

The five children of Arthur and Gertrude Pratt are shown here *c.* 1917. In the front are Angus and Donald; in the back from left to right are Vera, Stuart and Harvey. (EDR.)

In this c. 1927 photograph, Argie Pennington appears very serious, while little brother Henry Douglas (Dent) thinks it's really funny. (LRPG.)

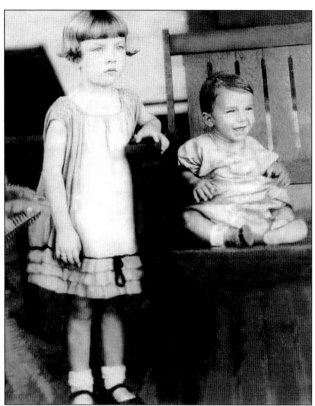

Shown here c. 1936 is Katie Harrelson, daughter of Alfred and Leonora Pitts Harrelson. (LRPG.)

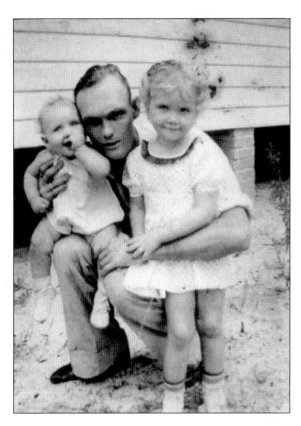

Bob Woodham hugs his daughters Annice, right, and baby Charlotte in the yard at their home. "Daddy had been sick. The doctor said he could no longer work inside the mill (Southern Kraft Paper Mill) because of his lungs, so he was eventually transferred to the woodyard," Annice recalls. (AWA.)

Catherine Woodham is shown with her daughter Annice, left, and cousin Ann Pratt, right, in 1937. Annice was two years old on February 20 and Ann's birthday was July 30. The little girls were "first best friends" and still are in 2003, although at a long distance. This photograph was made on Pratt Point. The home of Arthur and Gertrude Pratt is in left background. (AC.)

First cousins Ann Pratt (daughter of Stuart) and John Charles Raffield (son of Vera) have fun with a swing made by Grandpa Pratt, c. 1940. (AC.)

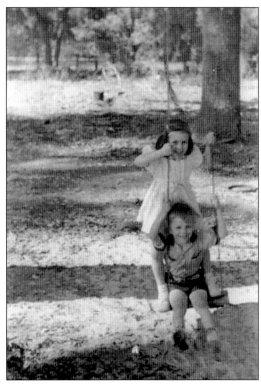

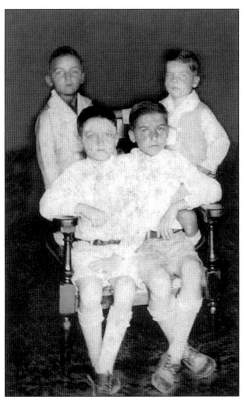

Four of Henry and Rosa Pennington's sons are shown here. Gordon and Dent are in front with Billy and Whit behind them. A younger sister says she never saw them that quiet and serious. (LRPG.)

The photographer must have told these little girls to "watch the birdie" on January 12, 1940. Charlotte Woodham, left, is two years old. Her sister Annice, center, and cousin Ann Pratt are five. (AC.)

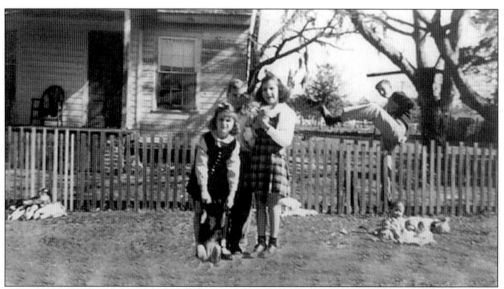

In the Pennington yard (from left to right) Donna, Horton, and Booty Pennington are playing with Jitterbug, their dog, and their doll collection, as their brother Whit jumps over the fence. (LRPG.)

Here is Stuart Pratt with his daughter Ann (born July 30, 1935). Stuart had graduated from the University of Florida with a degree in business administration, but it was the Depression and there were few jobs. He worked as a cargo checker on the steamer *Tarpon*, until Southern Kraft opened the paper mill just west of Parker, and he started in the labor crew. He progressed through the paper testing lab to become a statistical clerk. He was chief clerk when he retired. (AC.)

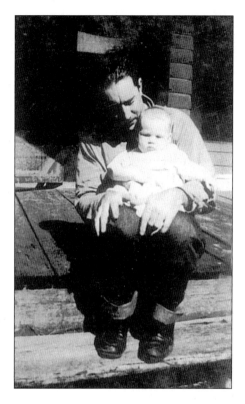

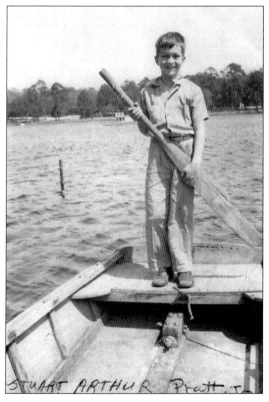

Arthur Pratt, in an old skiff with a broken oar, seems to agree with Rat's proposal in *The Wind in the Willows* that there is nothing, absolutely nothing, so fine as "simply fooling around in a boat." The boat is on Pratt Bayou c. 1947. (AC.)

Cousins Peggy Sue Parker (top left) and Ann Pratt are shown in the traditional studio pose; their sons, Ron Sarvis (left) and Soxie Houpt are shown below. (PSPM and AC.)

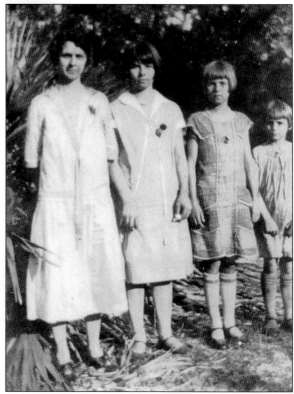

Jessie Parker is pictured with her three older daughters (from left to right) Jessie, Edwina, Virginia, and Florence. (AM.)

Eight-year-old Pearl Robbins seems to be saying "I dare you!" to someone in this snapshot, c. 1931 (BRN.)

Ann Pratt seems bothered by gnats while cousin Annice Woodham looks on, c. 1939 (AWA.)

a mother that would not be a mother

We got two Rabbits and I got
the mother Rabbit. We did
not know that she was going
to have babies and we did not
take out the father. So he
killed 3 of them. We put him
in a box but he got out. and he
got in to mr. peel's garden
and ate his vergdebul's. He asked
his frind's but they said that
it was are's and it was.
But There was more troubl my
rabbit would not feed her babies.
And There was only two
left. And they got dieriea. Then
my rabbit would not mate
again when we tryed to
mate her. But later on we
mateed her. And we put a box
in her cage but she put her
nest on the wire. And she would
not feed her 3 babies. We have to
hold her down. There are 2 black ones
and 1 white one's. But she's still
a mother that would not be a mother

Melissa Houpt was the eight-year-old owner of a mother rabbit. This is the true story she wrote in third grade in 1969. (AC.)

Five

PARKER SCHOOL

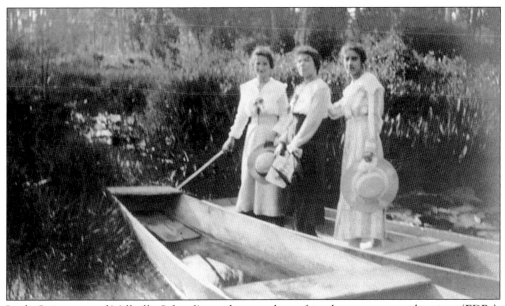

Leah Goins, one of Millville School's teachers, and two friends prepare to go boating. (EDR.)

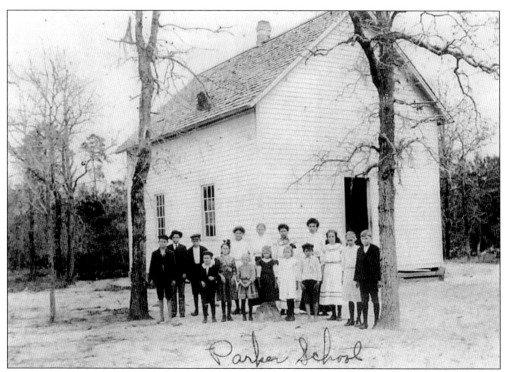

Parker School in 1908 was held in this building, which served as a church on Sundays. It was a one-room frame building located on the lot where the fire station is today. Students are, from left to right, (front row) Stuart Pratt, Myrtie Stevens, unidentified, Pearl Weekley, unidentified, Earl Parker, Sarah Vickery, Della Fox, and Charles Stewart; (back row) Zeke Stevens, Jim Davis, unidentified, Emily Wilson, Ethel Stewart, Lula Vickery, and Miss Stella Munson, a teacher who boarded in the home of Mrs. Arthur Pratt. Methodists and Baptists worshiped together in the building called the Union Church. (AC.)

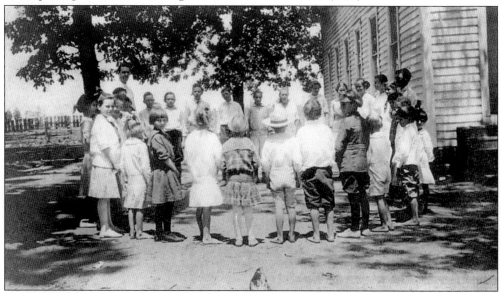

This photograph could be a class or it may be recess c. 1917. (EDR.)

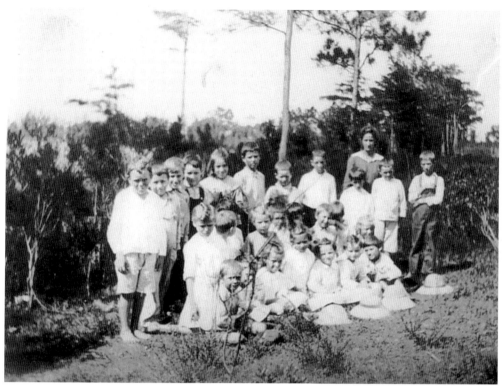

Leah Goins was a teacher at Millville School *c.* 1917. She is in the back row at right. (EDR.)

Leah Davis taught Millville School as a young woman. She left teaching to raise a family, and upon the death of her husband went back to teaching at Parker. She graduated from Florida State University, taught school, and raised three daughters and a son. Two of the daughters became teachers as well. (EDR.)

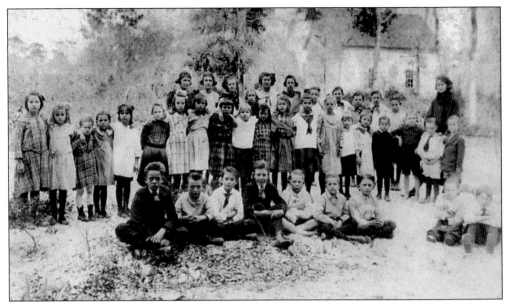

This 1920 photograph is from Edwina Parker Sweeney's collection. She is eighth from the right in the second row, and was 10 years old. Her notes listed the students as follows: (front row) (seated) Henry Fox, ? Underwood, Paul Parker, Harvey Davis, Leon Davis, Hadley Parker, Arthur Faircloth, Leo Percival, Donald Pratt; (second row) Iduma Underwood, Christine Percival, Hettina Fox, Virginia Parker, unidentified, Lucille Faircloth, Gladys Davis, Georgia Davis, Corine Davis, Mabel Percival, Bernice Boyd, Edwina Parker, Susie Fox, Ruth Palmer, Marcel Davis, Angus Pratt, Curtis Davis, Harold Pratt, Fred Percival; (back row) Edna Parker, Rosa Pitts, Lucy Davis, unidentified, Carrie Percival, Leanora Pitts, Roy Palmer, Danny Percival, Ralph Palmer, and teacher Miss Baum. (FPG.)

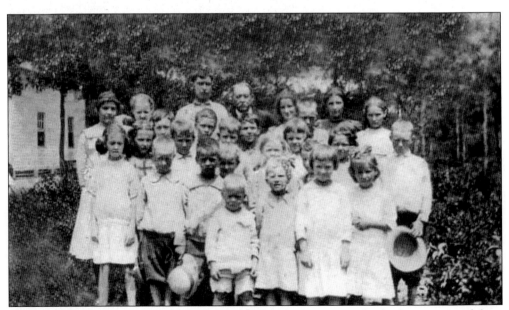

This could be a school or church group c. 1920. Rosa Pitts is on the back row, second from right. (LRPG.)

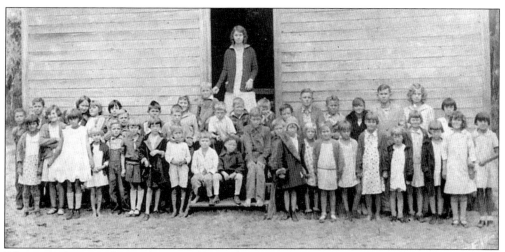

Edwina Parker was the teacher at Parker School in 1930–1931. She identified the students as follows: in the front row (from left to right), Grace Hewitt, Ruby Mayo, O.Z. Fox, Pearl Robbins, L.L. Davis, Louise Strout, Argie Pennington, Russell Percival, James Richie, Ford Birks (?), Delbert Faircloth, Louise Jones, Louise Fox, Lucile Mayo, Madeline Fox, Marvelle Robbins, Margaret Davis, Estelle Richie, Mary Evelyn Hinson, Nellie Cheney (?), and Lucy Mae Burk; in the back row, Lloyd Davis, Millard Sellars, Mildred Jones, Bessie Livingston, Lillian Ligon, Willard Sellars, Charles Parker, Rayborn Perdue, J.M. Jones, Alonzo Barnett, T.J. Perdue, Jimmie Barnett, Bobbie Maxwell, Duckie Mayo, David Davis, Hewell Pratt, Leo Percival, Catherine Pratt, Angus Pratt, Dellie B. Sellars, and Mary Hewitt. (FPG.)

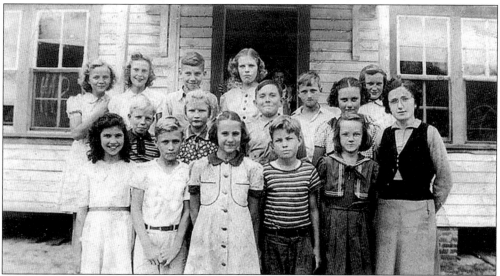

Shown is Lucille Moore's seventh- and eighth-grade class in 1940. In the front row, from left to right, are Jeanette Lambert, Fletcher Harrelson, Carolyn Parker, Lewis Creamer, unidentified, and Lucille Moore; in the second row are Arnold Davis, Evelyn Marchant, Emory Hobbs, Gordon Pennington, Ann Hobbs, and Florence Lee; in the back row are Ovita Stone, Ruth Robbins, Troy Pennington, and Luverne Davis. Miss Moore was a teacher and later a principal for many years. Drummond Park School was renamed Lucille Moore Elementary School in her honor. When she retired, her Parker students held a reunion at Parker School honoring her. (RPG.)

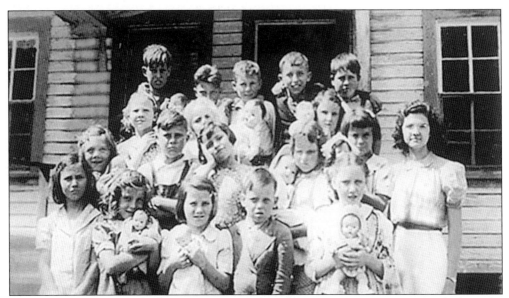

Miss Tillman's 1939 third- and fourth-grade class is shown in front of the old school where the city fire station is now. From left to right, in the front row, are Margaret Shivers, Rosemary Pennington, Ida Mae Lightsey, Ronnie Pitts, Dorothy Wright, and Miss Josephine Tillman; in the second row are Paula Bailey, unidentified, Jean Weeks, and Margaret Childers; in the third row are Aileen Gilbert, Joyce Grantham, and unidentified; in the fourth row Amos Messick, C.A. (Rusty) Stone, James Rudd, Charlie Weeks, and Ralph Messick. (LRPG.)

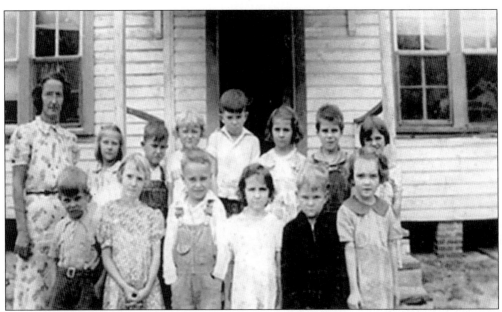

Mrs. Leah Davis is shown in 1939 with the second graders in her first- and second-grade class in front of the old school. From left to right are (front row) Bobby Pitts, Clara Nell Davis, Bobby Cobb, Laura Ruth Pennington, Joe Robbins, and Mildred Lee; (back row) Leah Davis, Katie Harrelson, Wayne Brown, Monette Gilbert, J.W. Traywick, Peggy Sue Parker, Clifford Lightsey, and Hazel Parker. (LRPG.)

This is Peggy Sue Parker (wearing crown, rear right), Parker School queen with the members of her court in front of her. (LRPG.)

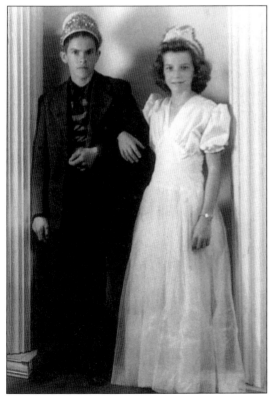

This photograph is of sixth graders Henry Vickers and Rosemary Pennington, king and queen of Parker School in 1942. (LRPG.)

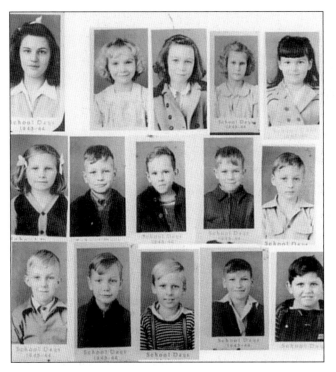

Shown here is part of Mary Frances Miller's 1943–1944 third grade. She was asked to "just take this class for two weeks, until we can get a teacher." A 1943 graduate of bay High School, she seemed to be a born teacher and all of her students adored her. It was two years before she could enter Florida State University. Shown from the top, left to right, are Mary Frances Miller, Annice Woodham, Ann Pratt, Betty Robbins, and Elizabeth Cox; (middle) unidentified, Jimmy Jones, Stanley Parker, Rodney Davis, and Don Palmer; (bottom row) Billy Akins, Vernon Lee, Julian Webb, Horton Pennington, and Bradley Pitts. (Courtesy MFMS.)

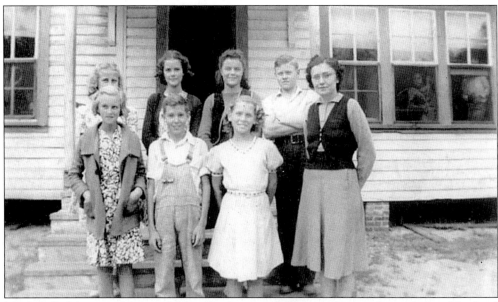

Ms. Lucille Moore and her eighth-grade class are shown standing in front of the old school in 1940. They are, from left to right, (front row) Mildred Davis, James Lambert, Doris Jean Parker, Ms. Moore; (back row) Hazel Perdue, Marjorie Davis, Audrey Byrd, and Raymond Donn. (EPG.)

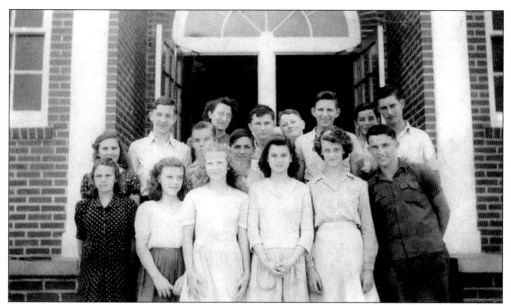

Rosalie Stanfill Hagan's 1944 eighth-grade class poses on the steps of the "new" school. From left to right are (front row) Margaret Pridgen, Paula Bailey, Aileen Gilbert, Betty Joyce Parker, Shirley Teall, and Charlie Weeks; (back row) unidentified, Dale McElreath, Earl Franklin, Billy Pennington, Glenn Roberts, Robert Wood, Houston Fox, unidentified, and Amos Messick. Mrs. Hagan stands behind the class. (LRPG.)

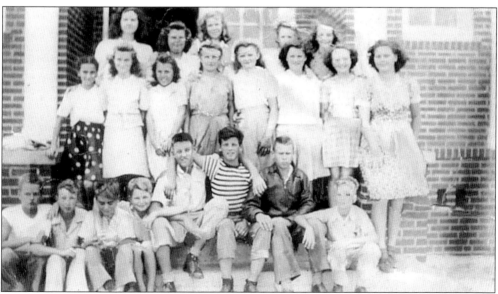

Miss Tillman's seventh-grade class in 1945 gathered for a photograph. From left to right are (front row) Edward Dozier, Bazil Williams, Jimmy Reid, Joe Robbins, Ralph McElreath, Duane Fox, and two unidentified; (middle row) Laura Ruth Pennington, Jackie Wilson, Addie Ruth Bell, Katie Harrelson, Monette Gilbert, Jean Weeks, and two unidentified; (back row) Miss Josephine Tillman, Willie Mae Sims, two unidentified, and Mildred Lee. (BRN.)

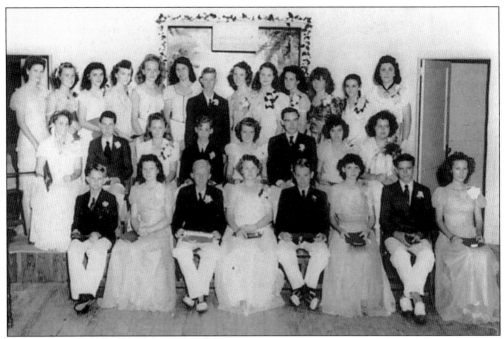

This is the eighth-grade graduating class of 1946. They are, from left to right, (front row) Joe Robbins, Delilah Jones, Crook Stewart, Katie Harrelson, Edward Dosier, Hazel Parker, Add Thomas, and Thelma Rudd; (middle row) Doris Jean Weeks, Edward Miller, Monette Gilbert, David Hill, Jackie Wilson, Robert Lee Payne, Addie Ruth Bell, and Willie Mae Sims; (back row) Miss Zerlene Shuler (teacher), Hattie Mae Mobley, Irene Prickett, Mildred Lee, Joan Adams, Hazel Finley, Bazil Williams, Clara Nell Davis, Grace ?, Betty Willis, Betty Ruth Morris, Laura Ruth Pennington, and Principal Lucille Moore. (CS.)

Bertha Hoskins Parker was a teacher at Parker School for many years before deciding to go into pre-school education. She opened a kindergarten in her home, and was well loved in the community. She also was very active in Parker Methodist Church. (EKP.)

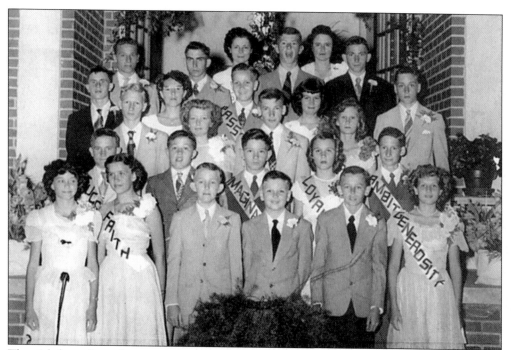

The eighth-grade graduating class of 1949 includes from left to right (first row) Lorene Tharpe, unidentified, Billy Akins, Jimmy Jones, unidentified, and Jean Biggs; (second row) Rodney Davis, Jack Bell, Billy Dail, Mary Lizzie Bell, and unidentified; (third row) Horace Williams, Joan Adams (?), Horton Pennington, and Betty Robbins; (fourth row) Charles Powell, Elizabeth Grice Vernon Lee, and Ann Pratt Don Palmer; (fifth row) George Pridgen, Ken Fugate (?), Bob Getty (?), and J.T. Moye; (sixth row) principal Edwina Sweeney and teacher Florence Stetson. (MFMS.)

The champion basketball team of the Class of 1949 includes, from left to right, J.T. Moye, Horton Pennington, Bob Getty (?), Don Palmer, and George Pridgen. (MFMS.)

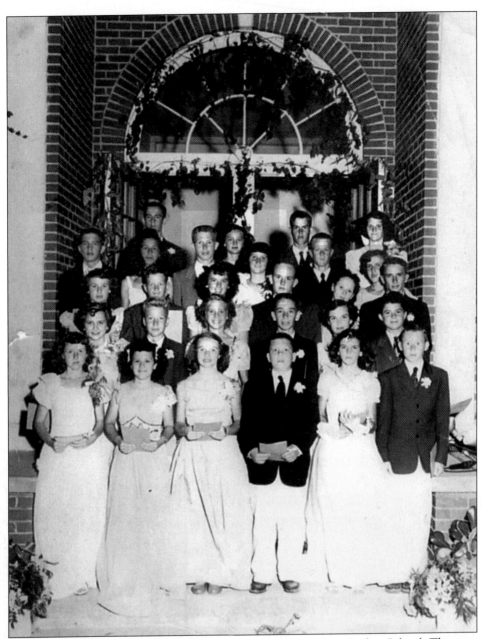

The Class of 1950 was the last eighth-grade class to graduate from Parker School. The county was building two junior high schools. The next year Parker included first through sixth grades. Parker students in seventh, eighth, and ninth grades would attend Everitt Junior High. The class is, from left to right, (first row) Virginia Powell, Joan Percival, Sally Lanier, Broward (Bud) Bailey, Donna Pennington, and Ellsworth (Red) Richie; (second row) Gay Crutchfield, Frank Hanna, Pat Eichelberger, Gerald Holley, Margaret Creamer, and Charles Tharpe; (third row) Janelle Ward, Harlen Wilson, Yvonne Weeks, Stanley Parker, Laneita Lanton, and Leland Messick; (fourth row) Jimmy Roberts, Frances Durden, Bill Miller, Myra Shiver, Tommy Whitted, and Beth Stewart; (fifth row) Raymond Holley, Thelma Nelson, Warren Richie, and Mavis Shiver. (MFMS.)

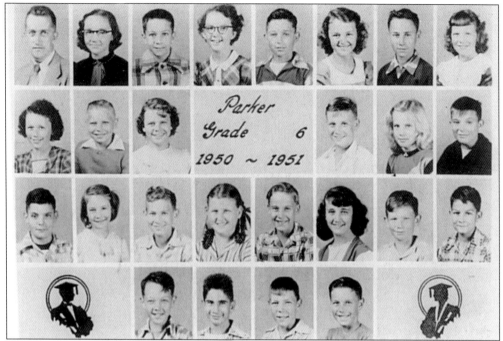

This is Mr. Wiant's sixth-grade class, 1950–1951. From left to right are (top row) Mr. Wiant, Joyce Gilbert, Arthur Pratt, Dorothy Redmond, unidentified, Phyllis Carter, unidentified, and Virginia Wilson; (second row) Avis Wood, Jerry Pridgen, Betty Whiddon, Bobby Whiddon, Ann Martin, and Wendell Davis; (third row) unidentified, Sharon Foreman, Robert Burleson, Carol Spicer, Loren Hendley, Joan Teall, and two unidentified; (fourth row) Stanley Cates, William Wood, Fred Bailey, and Clayton Chetwood. (AC.)

The children of Walter and Dorothy Teall, from left to right, are Larry and Cindy (top) and Susie and Ronald

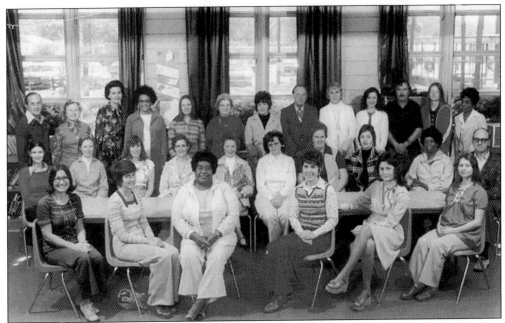

This is the Parker Faculty in 1976. From left to right are (front row) Mary Gibson, Thelma Bruce, Verdell Stringer, unidentified, Blonza Layfield, and unidentified; (middle row) unidentified, Tony Addy, Maureen Knipper, Marjorie Pollock, Lucy Sweatt, Argie Garrison, Tulia Smith, unidentified, Alvada Wilson, and Bill Bailey; (back row) Dick Locher, Gertrude Kendrick, Mary Frances Shores, Evelyn Campbell, Carolella Trapp, Maisie Lewellyn, Doris Featherstone, Leonard Smith, Jane Hatton, unidentified, Joe Bradshaw, unidentified, and Mary Russ. (MFMS.)

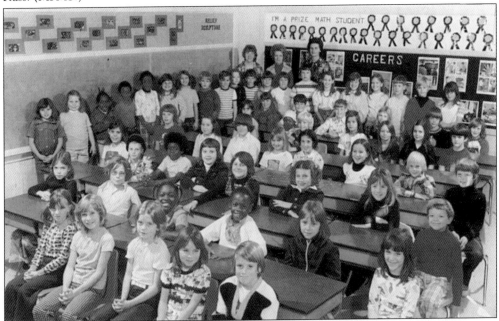

This is the third grade in 1976. Aides Sylvia Phelps and Jackie Swearingen and third-grade teacher Mary Frances Shores (right) are standing in the back.

Six

CHURCHES

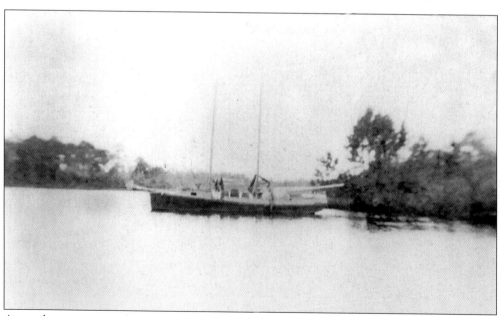

An anchorage seems a fitting image to introduce the churches of Parker. (EDR.)

This building was called the Union Church and was attended by Baptists and Methodists. Prior to 1900 circuit riders provided services once a month—one month Methodist, the next month Baptist. In between these times the congregation attended a Union Sunday school. In this *c.* 1910 photograph, Gertrude Pratt is fourth from left and Arthur Pratt is fifth. Their eldest son, Stuart, is in front with his hands on his hips. (AM.)

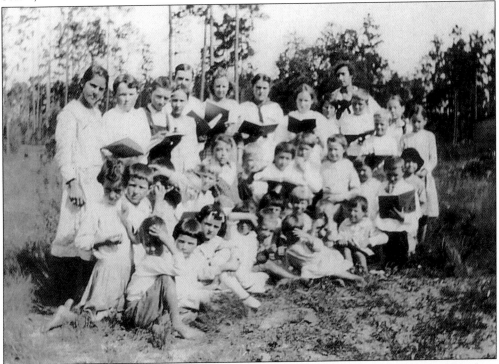

Parker School also met in the Union Church building. This appears to be an outdoor choir practice. (EDR.)

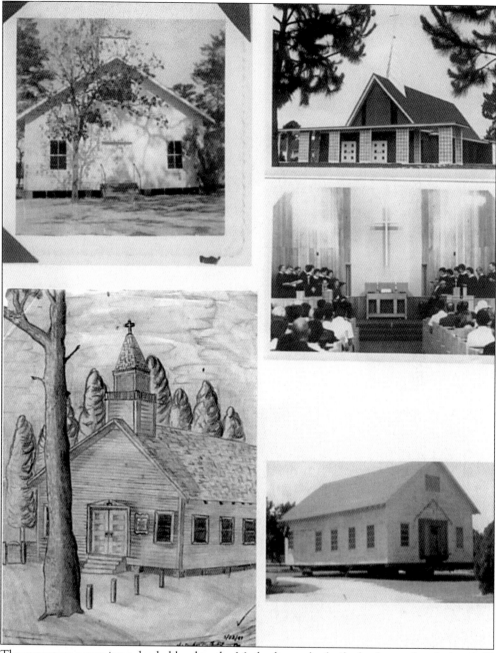

The cemetery committee deeded land to the Methodists, who built the frame church (top left) and invited the Baptists to worship with them. They did, until 1943, when they began a building program. The Methodists stayed on the corner of the cemetery until 1958, when they moved the church building to the Parkway (bottom right) and later built the sanctuary (top right). The drawing was done in 1949 by Arthur Mashburn, who was 16. (MPC and AM.)

This group was photographed during Bible School at First Baptist Church of Parker. Steve Bates, far right, was the leader. (FBCP.)

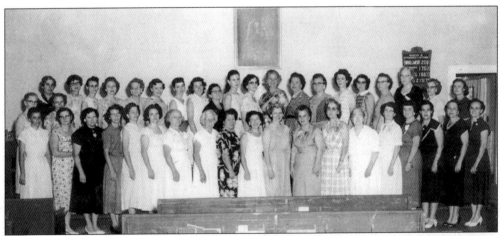

Parker Methodist Women's Society of Christian Service members are pictured here in 1958. From left to right are (front row) Joyce Worthington, Mrs. Gilmore, Verna Mae Carter, Dorothy Teall, Thelma Pratt, Jean Melvin, Emalie Percival, Mary Davis, Mrs. Green, Mrs. Rizutto, Edwina Parker Sweeney, Mrs. Newton, Iva Holley, Gertrude Pratt, Mrs. MacWilliams, Edith Clark, Lillian Pratt, Estelle Watts, and Marcella Parker; (back row) Bertha Parker, Mrs. Tyndall, Myrtice Parker, Haley Spicer, Louise Burch, Betty Hill, Nettie Gilstrap, Mrs. Neal, Mary Chestnut, Edith Hutchinson, Mrs. Wilson, Carol Spicer, Eldis Martin, Joyce Robertson, Mrs. Thomas, Mrs. Childers, Ruby Mashburn, Pauline Mashburn, Mrs. Lee, Mrs. Perkins, Ethel Teall, and Dora Lee Davis. (PMC.)

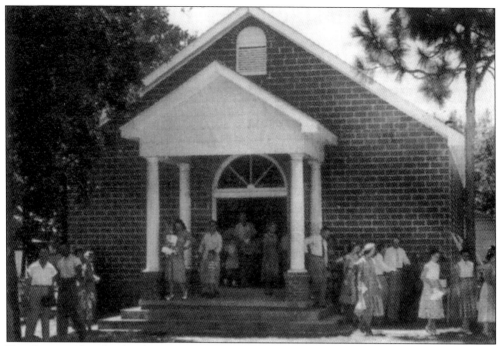

First Baptist Church of Parker was organized in 1943, with 32 charter members, and worshipped God in a two-room residence. By 1946 a new brick building was completed and the pews, piano, and songbooks were donated to the church. A second building campaign was in 1954–1968. A third campaign began in May 1982, and in July 1988 the worship center was completed in time for the church's 45th anniversary.

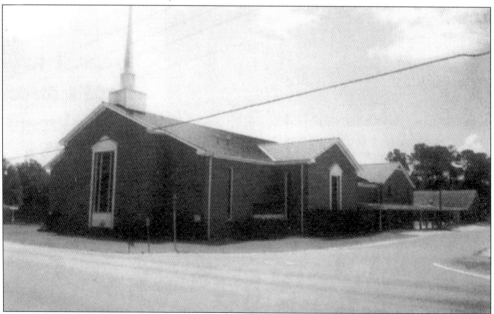

With a wonderful history, an eventful present, and an exciting future, the church's goals are to honor Christ, to care for and love one another, and reach out to the community with the love of our Lord and Savior. (FBCP.)

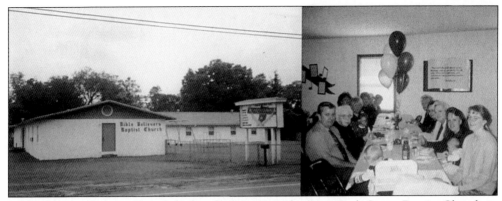

Bible Believers Baptist Church had its beginning as the West Park Street Baptist Church in 1969, later became Trinity Baptist Church, but has had its present name since 1984. On August 7, 1985 Greg Rhinehart became pastor. Preaching the Gospel is the main focus of the church, he said. In addition, the congregation supports 70 missionaries around the world. He also preaches at the jail. During a fellowship dinner at the church the people at this table were snapped by the photographer. On the left side of the table are Pastor Rhinehart, Hazel Dillingham, Leigh Ann Parent, Dorothy Galloway, and two unidentified; in the high chair is Duncan Rhinehart; and on the right side of the table is Melanie Rhinehart, baby Laura Jean Parent, Joy Parent, Diane Ake, Glenda Rhinehart (visitor), and Lavelle Hughes. (BBBC.)

This happy-looking group includes young people in the First Baptist Church of Parker youth group. (FBCP.)

74

Seven
PASTIMES AND LABORS

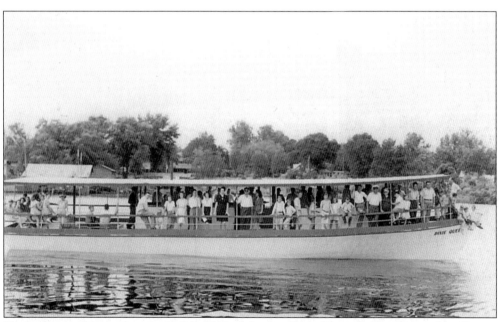

Shown here is the maiden trip in July 1946 of the first *Dixie Queen*, built in his yard by George Davis and transported on rollers (logs) down the street to the bay. This first vessel was the beginning of the Queen Fleet, operated by Davis and his sons, Edsel (Duck), Joe Ed, and Grover. The photo shows the Davis family and many of their friends and family in Parker. Among them are Fire Chief Roy Roberts and his wife, Evelyn. (EDR.)

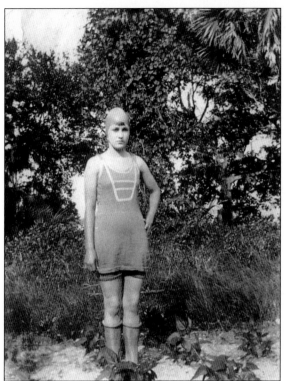

It is no surprise in a community surrounded on three sides by bay and bayou that its residents enjoy water sports. Shown is an unidentified young woman c. 1924 in a swimming suit complete with stockings and cap. It is a bit more attractive than the suits worn by the young men. (AC.)

Rosa Pitts Pennington swims in the bayou with her little daughter, Argie. (LRPG.)

Stuart Arthur Pratt is in the surf, perhaps on the gulf beach at Cromanton, *c.* 1918. (AC.)

An unidentified young man is headed for a swim in the bayou. (EDR.)

Beulah Parker enjoys an outing on the bay beach's white sand and in its clean water. (EPC.)

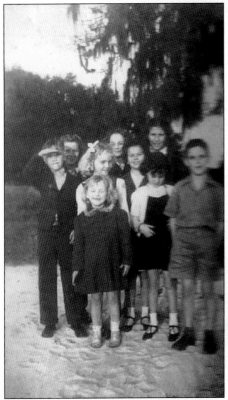

When your front yard is the bay you can have birthday parties on the beach, as Annice Woodham did c. 1944. From left to right are (front row) Charlotte Woodham and Earl Carter; (middle row) Vernon Lee, Annice Woodham, Elizabeth Cox, and Ann Pratt; (back row) Jackie Wilson, Mildred Lee, and Peggy Sue Parker. (AWA.)

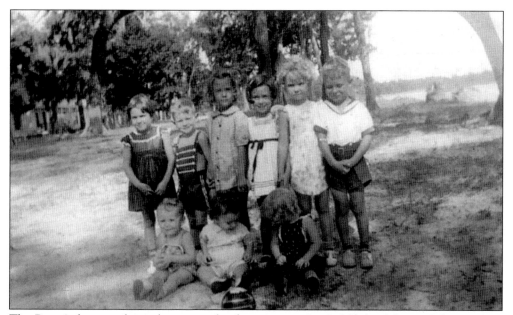

The Pratts's front yard was the setting for this party on Ann's fifth birthday on July 30, 1940. From left to right are (front row) Donna Youngblood, Arthur Pratt, and Charlotte Woodham; (back row) Elizabeth Cox, John Charles Raffield, Jackie Byrd, Ann Pratt, Annice Woodham, and Dickie Youngblood. (AC.)

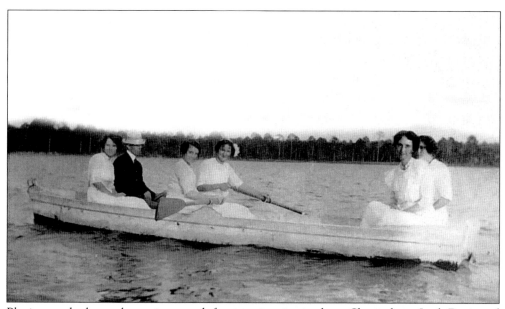

Playing on the bay or bayou is as much fun as swimming in them. Shown here, Leah Davis and friends practice their rowing skills. (EDR.)

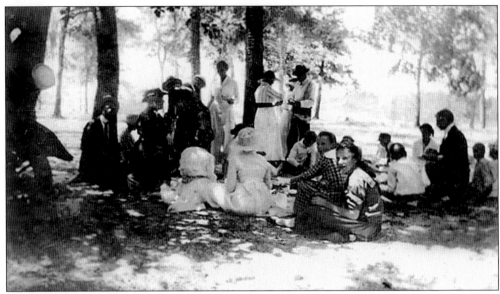

Picnics were a favorite pastime in Parker. This picture is from the Pennington family's collection. (LRPG.)

Then there was flower-picking. It seems in this *c.* 1917 photograph, Vera Pratt is enjoying the expedition more than her little brothers, Angus (left) and Donald. (AC.)

Shown here is the Charles Parker family's Easter 1926 picnic at Parker Branch. This freshwater branch flowed into Martin Bayou. (FPG.)

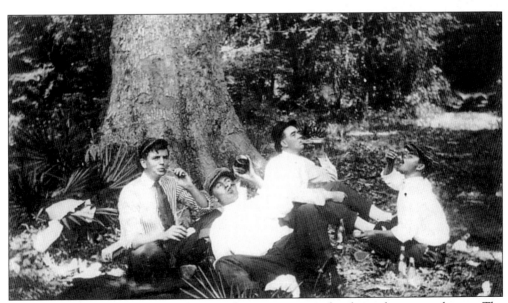

The unidentified youths in this photograph are enjoying either home brew or soda pop. The labels are illegible. (EDR.)

When the new road was built from Bay Harbor to Martin Bayou, and the wood frame bridge was built where the bayou flowed into the bay, for the first time the Parker community was connected to Bay Harbor and Millville by a land route. A note on the snapshot says "Bay County hard roads." People still used their boats for transportation, but now they had a new pastime—driving! (EDR.)

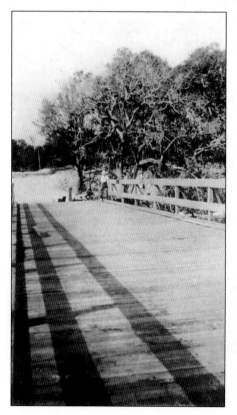

This span, first referred to as Martin's Bridge, was constructed after notice for the building contract was given and awarded in 1911. (EDR.)

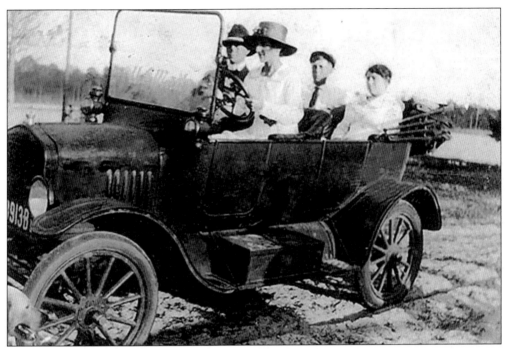

Young ladies discovered the automobile and knew that they could drive as well as any man. In this photograph Rosa Pitts is at the wheel of this car and takes friends for a drive. (LRPG.)

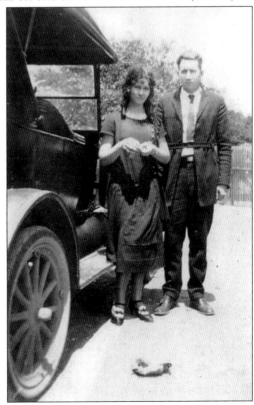

Sisters persuaded their brothers to let them go for a drive. Shown here are Vera Pratt and her older brother Stuart. (AC.)

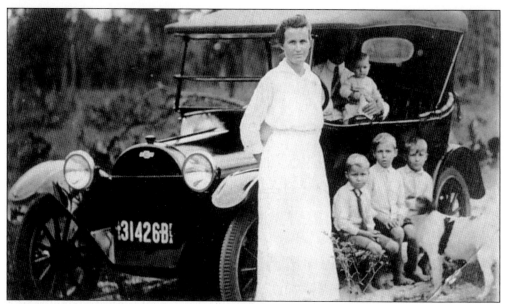

Autos were for families too. In this photograph Charles Arthur Mashburn is in the car with daughter Lona Inez. Annie Rebecca Tipton Mashburn leans on fender with (left to right) Buford Rivers, Cliff Bonapart, and Harry Reginald Mashburn. Harry R. Mashburn was born December 6, 1910. He must have been about eight years old at this time. (AM.)

Columbus C. Holley, left, and Charles Mashburn seem to be having a serious discussion. Note the sidearm. (LRPG.)

Bernice Anderson is shown here at 17. She and her sister Grace were boarding in St. Andrews while attending Bay County High School when she was introduced to Stuart Pratt, a cargo checker on the coastal steamer Tarpon. "That's the man I'm going to marry," she told her sister. And she did. (AC.)

Owning a sporty Ford coupe didn't hurt when courting a young woman. Stuart Pratt married Bernice Anderson November 16, 1933 when he was 31 and she was 18. (AC.)

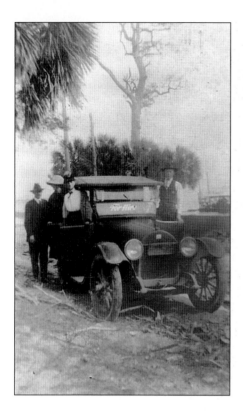

This is the first taxi in Panama City, owned by Doc Daffin's father, c. 1918. (Doc later became a sheriff of Bay County.) Martin Davis used to get the taxi to come to Parker when he was courting Leah Goins to take her for a drive. (EDR.)

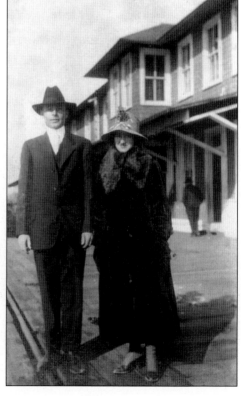

The back of this snapshot says "first picture of Mr. and Mrs. Martin Davis." Martin and Leah were at the train station in Panama City, going on a wedding trip. They were married on February 16, 1919. (EDR.)

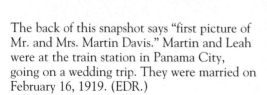

Shown here is a game of stickball. Note how long the bat (stick) looks. This picture could be of children playing at recess at Parker School when Leah Goins was the teacher. The older boys had a baseball team that played other communities. Bill Spicer said he played first base and Ed Parker was outstanding at shortstop. They beat teams from Millville and St. Andrews. (EDR.)

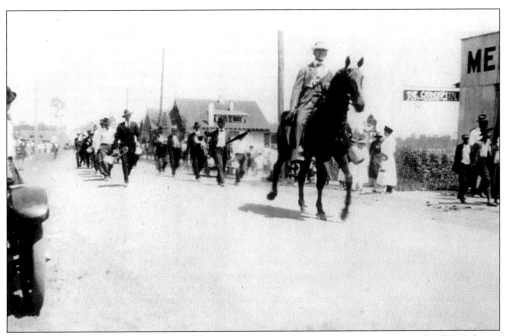

If you had transportation, you could go into Panama City to see the street parade. (EDR.)

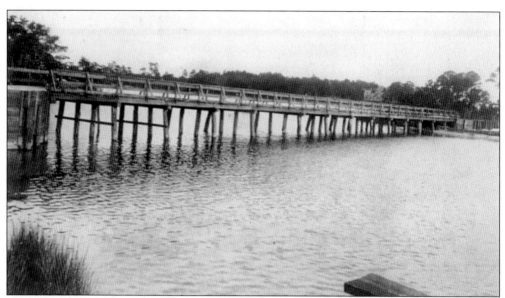

This view, from Leah Davis's album, is of the Pitts Bayou Bridge. (EDR.)

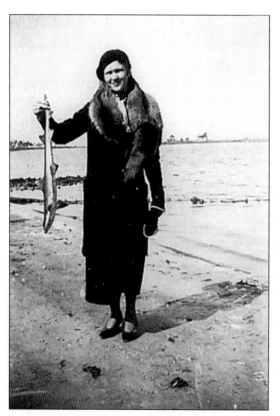

This photograph of Vera Pratt Raffield holding up a small shark was taken about 1926. It must have been cold that day. Seine nets can be seen in the water behind her. The boats must have been making a strike somewhere accessible, since Charlie brought her in the car. (Courtesy of John Charles Raffield.)

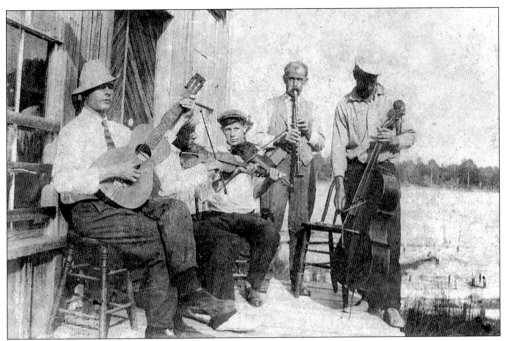

These musicians were playing on Election Day in 1913. From left to right are Martin Davis, guitar; Charlie and Delbert Davis, fiddles; W.H. Parker, clarinet; and an unidentified bassist. (EDR.)

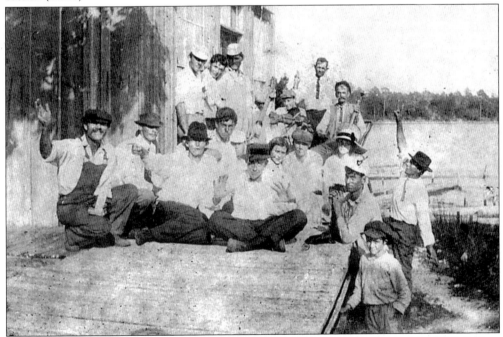

Here exuberant young men wave their arms. It was Election Day according to Mrs. W.P. Parker, who gave the picture album to Marion Davis for Christmas in 1914. Her notes say the election was to separate from Washington County and form Bay County in 1913, with Panama City as the new county seat. (EDR.)

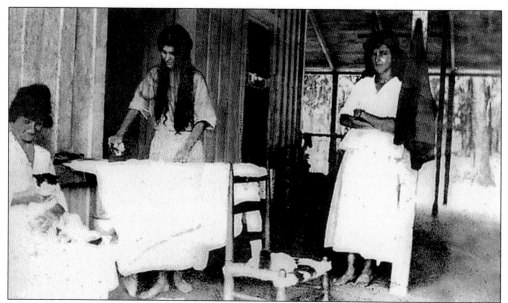

It was ironing day at the Pitts home. Arms folded, Rosa Pitts is watching someone else iron. (LRPG.)

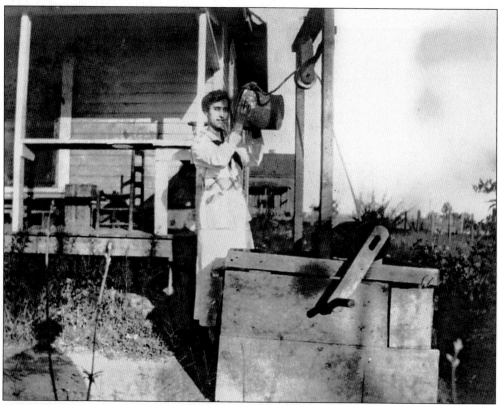

This well is conveniently close to the porch. (EDR.)

This photograph shows Russell "Jigs" Percival and Marvelle Robbins c. 1940. Jigs was a son of Frank and Emily Percival, longtime Parker residents. Marvelle was a great-granddaughter of Martin and Lovie Davis. Her parents were Harlie and Ethie Robbins. (BRN.)

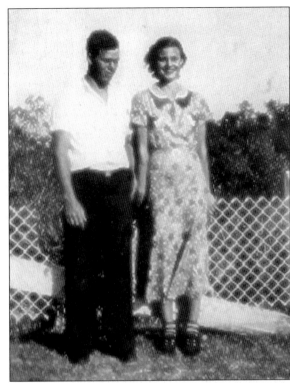

Bill Spicer and a friend go boating. (Courtesy Bill Spicer.)

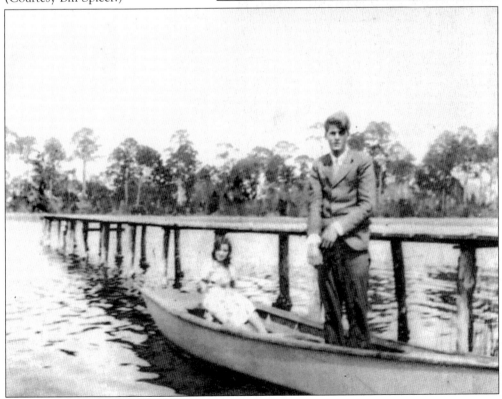

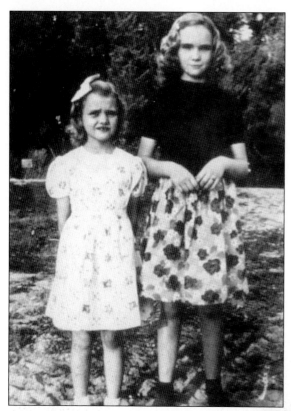

Charlotte and Annice Woodham are in front of their house. Annice is wearing one of her favorite skirts. Her mother made it of chicken feed sacks from her aunt's feed store in New Smyrna Beach. It had a turquoise background, bright red roses, and white daisies. Those were the 1940s when everything was scarce, and most Parker folks liked to get good feed-sack material. (AWA.)

Marvelle Robbins in this photograph is caring for someone's baby. (BRN.)

A favorite pastime in the 1950s was gathering with friends. Raymond Holley and Carol Spicer belonged to Parker Methodist Youth Fellowship. (BS.)

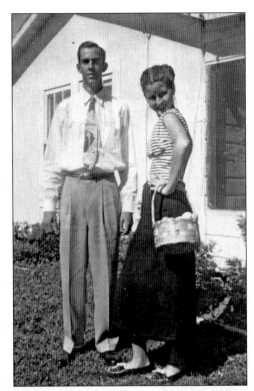

Sometimes you just hung out with your big brother. In this c. 1964 photo, Billy Dobbs, 11 months old, is being held up by big brother Scott, three and a half. (Courtesy Lucy Dobbs.)

Another favorite pastime was comparing grandchildren. Willie O. Pratt is holding her oldest grandchild, Annice Woodham, her daughter Catherine's first child, born on February 20, 1935. (AWA.)

Gertrude Pratt, Willie's sister, got her first grandchild July 30, 1935, when Ann Pratt was born. Willie and Gertrude were loving sisters, and the babies became first best friends. (AC.)

The Coca-Cola sign had Mrs. W.O. Pratt at the top and General Merchandise underneath. Catherine Pratt said this picture was taken in 1929, "but Mama bought, and went in business there, in 1921 or 1922. Located at the end of what is now Pitts Avenue, the store was first facing the bay. But when Mama bought it from Uncle Osgood (Parker) she had it turned so it faced the road. It was the only store in Parker for years." (AWA and CPW.)

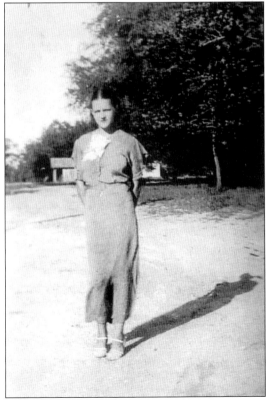

Catherine Pratt is shown with her mother's store in the background. "I can remember vaguely when we moved in," she said. "I was about three years old at the time, which must have been 1921 or 1922. I was frightened to death of the truck unloading groceries at the side door. It looked so big and made a lot of noise." (AWA.)

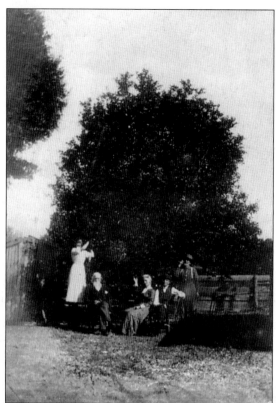

There were a lot of citrus trees in Parker in the early years of the 20th century. Shown here are (from left to right) Leah Goins (picking oranges), Dr W.P. Parker, Emma Parker, and two unidentified people at Dr. and Mrs. Parker's home. (EDR.)

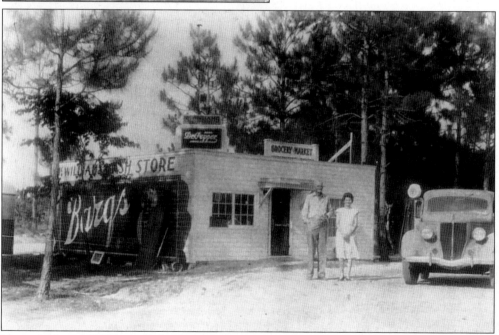

Mr. and Mrs. McWilliams, Haley Spicer's parents, stand in front of their store on what is now Boat Race Road in Parker. Over the Barqs sign is lettered "McWilliams Cash Store." (Courtesy of Bill Spicer.)

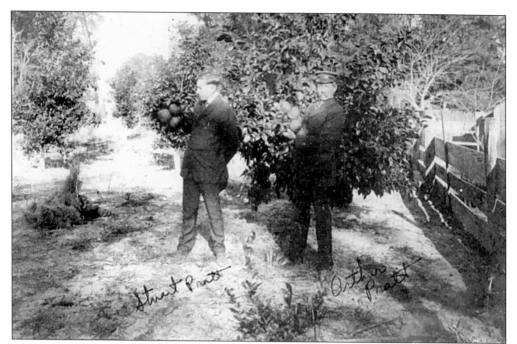

In this *c.* 1920 photograph taken at the Pratt place, Stuart Pratt and his father, Arthur L. Pratt, show their grapefruit tree. Stuart told his children that he could pick grapefruit off one tree from his second-floor bedroom. (AC.)

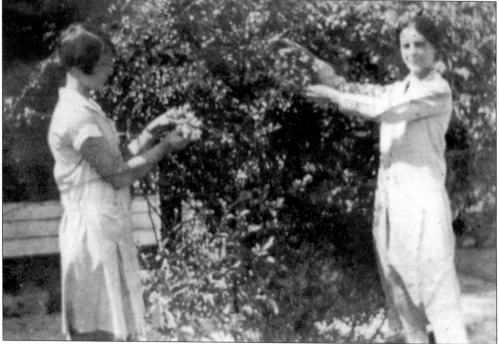

Edwina and her mother Jessie (Mrs. Charles Parker) inspect a flowering tree in their yard *c.* 1920. The Charles Parker home still stands on "the big curve" of Highway 98 in Parker, and is owned by Ken Thomas, a grandson of Charles and Jessie. (FPG.)

Another pastime was dressing up and having your picture taken. This young lady is Jessie Pitts Brown, daughter of Noah and Rebecca Parker Pitts. She married Richard Brown. The couple lived in the old homestead on Pitts Bayou. (LRPG.)

Shown here is Sadie Raffield Pennington. She married Will Pennington and they had two children, Bernice and Troy. (AC.)

Photographs often were exchanged between kinfolk. On the back of this photo is the message "To Gertie with love from her loving cousin Mollie." (AC.)

Most everyone had a garden, but some folks had real green thumbs. Here we see Haley Spicer showing off a large pumpkin. (BS.)

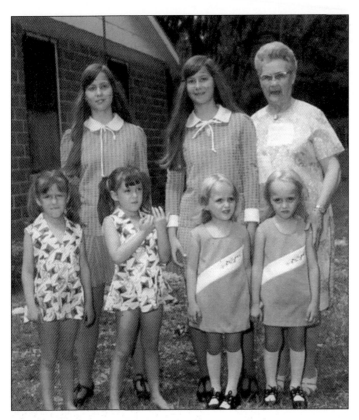

A favorite pastime was—and still is—family reunions. The twins in this photograph are all grown up now but they remember Grandma and this 1973 reunion. This is Mrs G.W. (Pallie) Anderson and the twins are all cousins. From left to right are (front row) Kelly and Kathleen Robinson and Stella and Stephanie Anderson; (back row) Paula and Pamela Stroud and Great Grandma. (AC.)

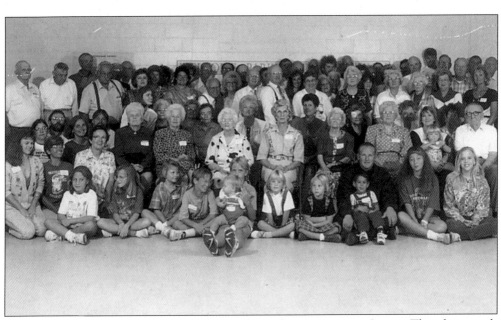

The Parker Reunion is held every October in the Parker Community Center. This photograph was made in 1993.

This photograph, taken from the Pratt's front yard, is of their next-door neighbor's sons and their sailboat. Their parents are Dick and Jean Dufresne, who settled on Pratt Point after they retired from the Air Force. They built their house here in 1975. They have four children, Richard, Mark, Michael, and Deborah. (Author's collection.)

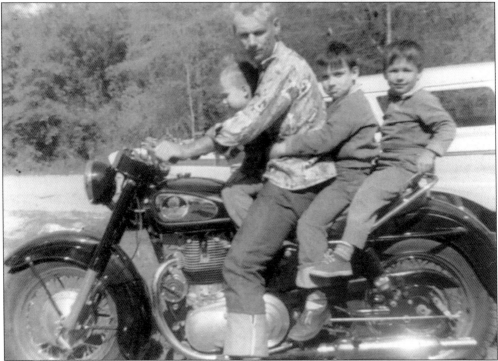

Phyllis and Bert Vineyard met in the United States Air Force and had a military wedding. They made their home in Parker (with a few military interruptions) and raised three sons. In this photograph Bert Vineyard gives his sons a ride on his new 1961 Indian. From left are Chuck, Bert, Michael, and Rick. (Courtesy of Phyllis Vineyard.)

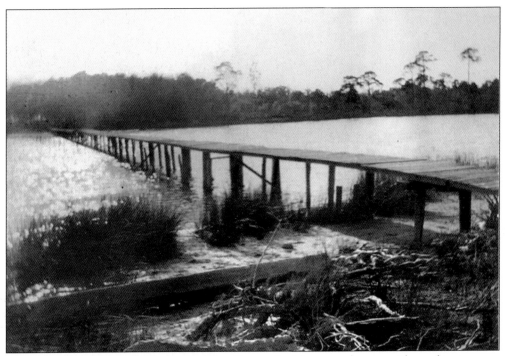

This is a view of the footbridge across Pratt Bayou. Residents on the west side used it as a shortcut to go to the post office. There were also narrow spans made of two planks that were built across marshes. They called them catwalks. (EDR.)

This well is conveniently close to the porch. (EDR.)

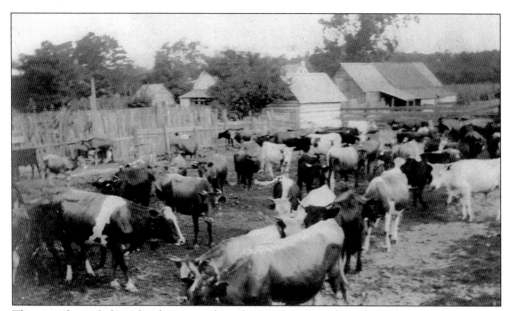

These cattle are believed to be pictured on the W.H. Parker place. (EDR.)

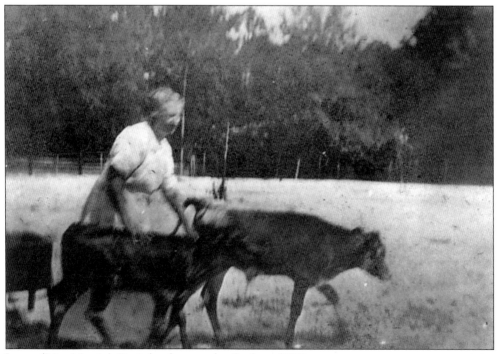

Lovey (Mrs. Martin) Davis herds a couple of calves. (EDR.

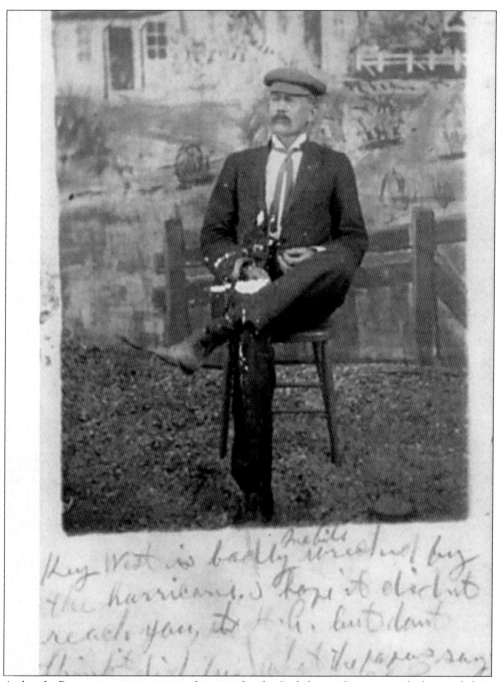

Arthur L. Pratt was a maintenance foreman for the Lighthouse Service, a job that took him from Fort Lauderdale, Florida to Galveston, Texas, repairing lighthouses and keepers' dwellings. Shown here is a postcard he sent his son in 1909 from Mobile, Alabama, on October 12, 1909. Stuart was seven years old. The handwriting is good, but the ink is fading. "Hello, Stuart. How are you? I hope your risings are all right by now, Do you know who this is on this card?" Under his picture he wrote, "Key West is badly wrecked by the hurricane. Hope it didn't reach you . . . but don't think it did, by what the papers say. ALP." (AC.)

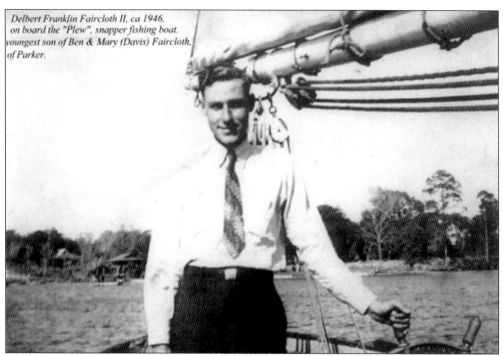

Delbert F. Faircloth stands at the helm of "The Plew," a snapper fishing boat he fished on. His brother, Harold Faircloth, was captain of this boat for many years. Delbert was Ethie Robbins's youngest brother. He served in the United States Coast Guard in World War II. (BRN.)

This is a view of Parker Bayou from near Percival's dock (front right). One can see Donaldson's Point at the upper left. Davis's seine reel is at upper right. (EDR.)

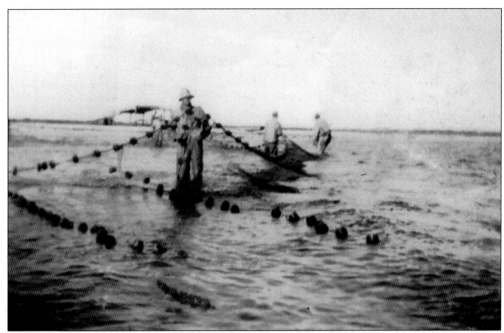

These fishermen making a strike are on Peter Parker III's crew. Bill Spicer is at the center, facing the camera. On one trip Parker brought in 80,000 pounds of fish. (Courtesy of Bill Spicer.)

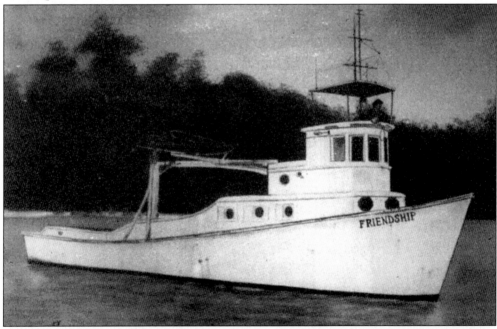

Capt. Ed Parker's boat, the *Friendship*, was well known on the bays and the gulf. He said he got just as big a thrill out of a good net catch as any sportsman catching gamefish. He was the son of Walter and Addie Hoskins Parker. Ed and his wife, Marcelle Davis Parker, had two boys and a girl, Stanley, Jack, and Phyllis. He was a net fisherman all his life, until Florida outlawed nets and shut down this industry. (Courtesy Ed Parker Family.)

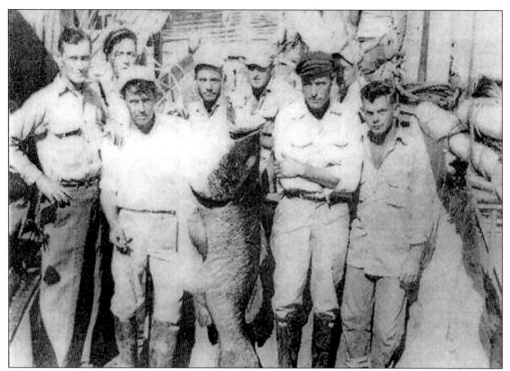

This 1950s photograph of a world's record red snapper caught aboard the fishing boat *J.E. Plew*. The captain is Harold B. Faircloth of Parker. The crew, from left to right, are (front row) Lester Jones, Russell (Jigs) Percival, Capt. Harold B. Faircloth, and Jimmy Tedder; (back row) Loyce (Chocolate) Harvard, Vester Jones, James Holden, and two unidentified. (BRN.)

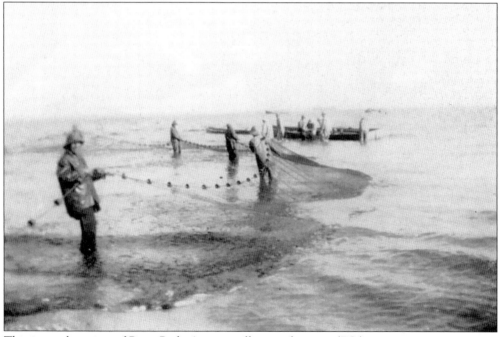

This is another view of Peter Parker's crew pulling in the nets. (BS.)

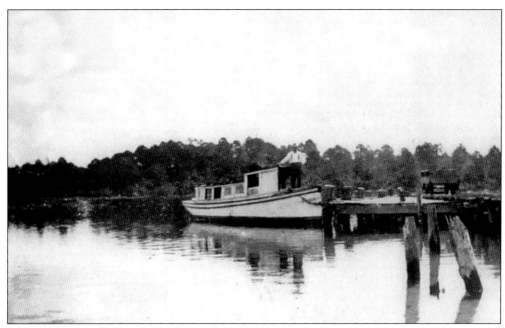

This is a boat docked in Parker Bayou. (EDR.)

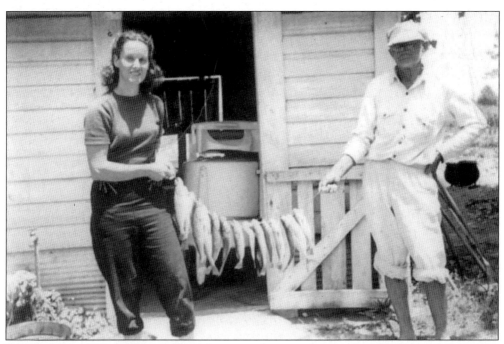

John Parker and his daughter-in-law Mary come home with a good catch. Fishing is a pastime for most, and labor for many. (EKP.)

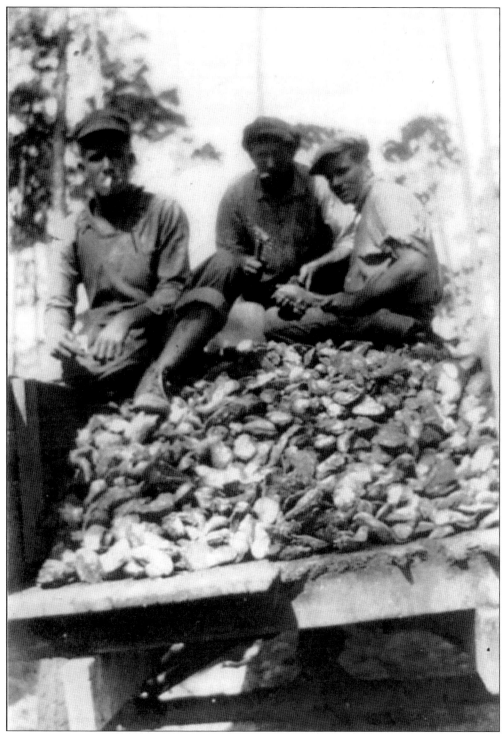

This c. 1925 photograph of a truckload of oysters and the men who harvested them is from Arthur Mashburn's collection.

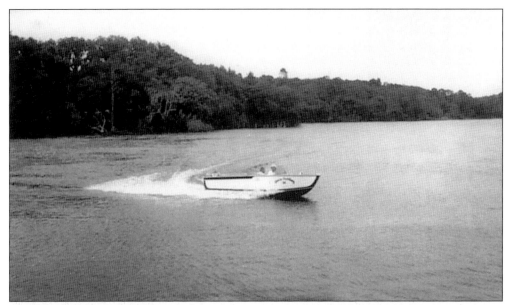

This is a boat manufactured by Carter Craft, a Parker-based company founded by James Carter and family. (Courtesy of Tom Bingham.)

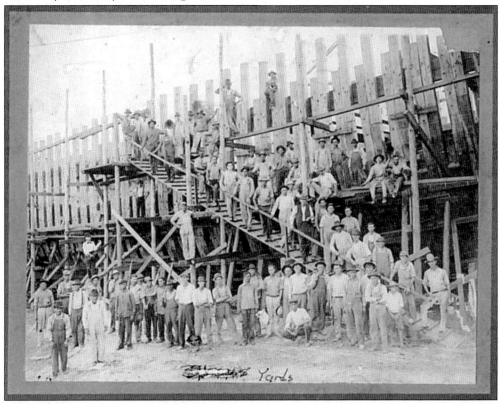

This c. 1920 photograph belonged to Arthur L. Pratt. He is the shipbuilder on top right. His son, Stuart, who worked to earn money for college, stands on the ramp, second from right (bottom). (AC.)

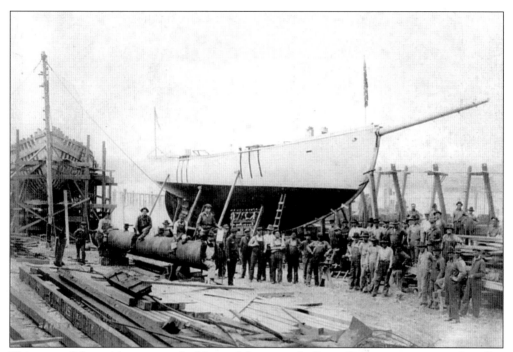

This crew of ship carpenters was building a fishing smack. Stuart Pratt is squatting on the roller (center). His father, Arthur L. Pratt, is in the crew, too. (AC.)

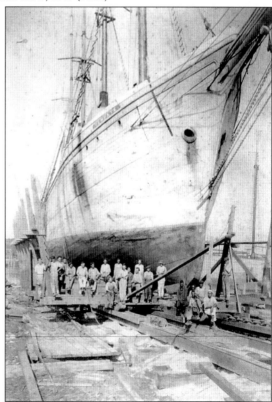

One of the bigger vessels built in the Millville yards was the *Tempate* and this work crew includes Arthur L. Pratt, seated at center and holding his hat. (AC.)

Ethlyn Parker is shown here. The wife of W.H. Parker, she was postmistress of the Parker Post Office for many years when it was located in the Lodge building. (EDR.)

A successor to Mrs. Parker as postmistress was Rosa Pitts Pennington. The post office was then located in a small building on what is now Pitts Avenue, next to the Pennington home. It can be seen in the background (right center) of this photograph of Whit Pennington. (LRPG.)

In this photograph Henry Pennington and crew are drilling a well. (LRPG.)

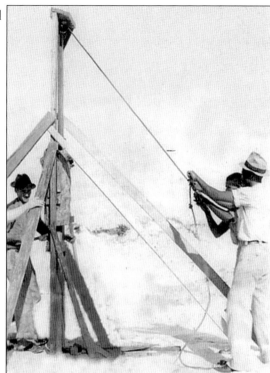

This photograph is from the United Brotherhood of Carpenters. From left to right are Henry Pennington, his son Gordon, unidentified, another unidentified person who received carpenter awards, and Mr. McKetcham. (LRPG.)

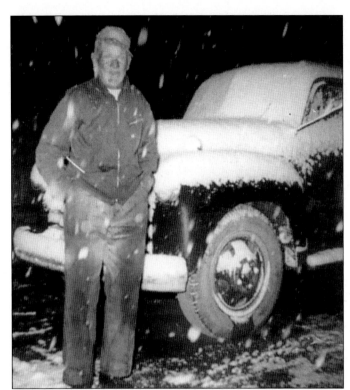

Smitty, a Two Crooks employee, shrugs his shoulders as snow coats the truck and the ground in 1958. (CS.)

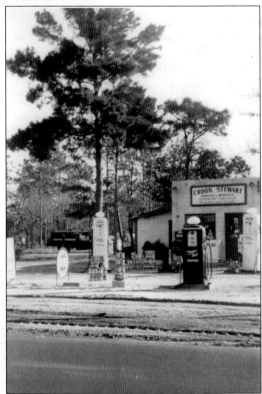

Snow stays on the ground, for a while, at Crook Stewart's filling station in 1958 on Highway 98 in Parker. (CS.)

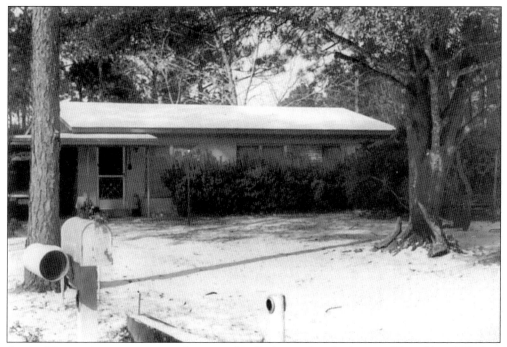

Again, 31 years later, snow coats the ground in Parker and at the home of Donald and Thelma Pratt. This was December 23, 1989. (Courtesy of Thelma Pratt.)

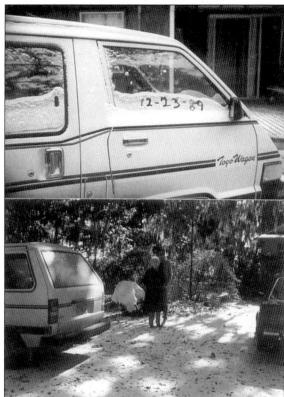

Bernice Pratt and her grandson Soxie Houpt stand in the backyard of her home. The Houpts were careful to write the date in the snow on the van window for a record of the snowfall. (AC.)

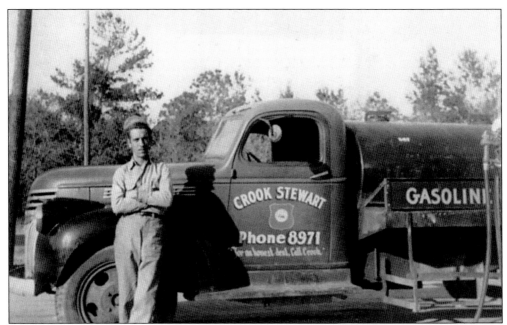

Employee Walter Teall leans against a Crook Stewart truck at the Parker business. (CS.)

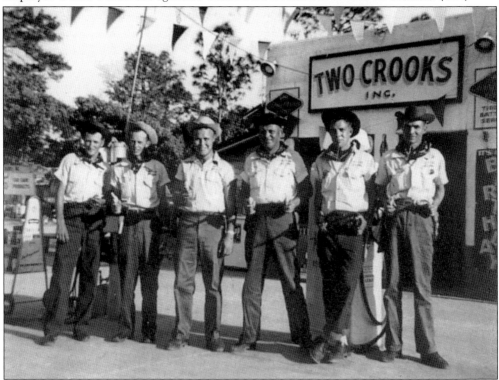

Crook Stewart included Crook Jr. in the fuel oil company and it became Two Crooks Inc. "For an honest deal see Crook" was the company motto. The employees are dressed up for the grand opening. Besides the filling station, Two Crooks distributed oil to heat the homes of Parker and surrounding areas.

Eight

THE WAR YEARS

Crash rescue boats were on the bay and gulf daily after Tyndall Field was built. Civilians along with military personnel were employed on the crews. Harvey Pratt was among them. (BCPL.)

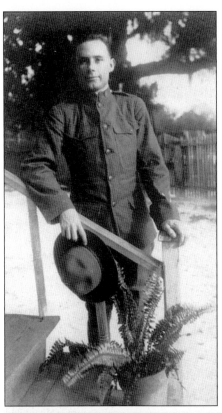

Martin M. Davis is pictured here in his World War I Army uniform. When Martin came back he married Leah Goins, adopted daughter of Dr. and Mrs. W.P. Parker. They had four children, Florence, Evelyn, Marjorie, and Alton (Buddy) Davis. (EDR.)

Parker men have served in every war. William Loftin was an officer in the War of 1812. Parkers joined the Confederacy; Pratts in Minnesota joined the Union. In World War I Harlie Lee Robbins (1895–1975) (left) and his brother Joseph Riley Robbins (1896–1999) served. Harlie served from May 26, 1918 to June 27, 1919 in Gen Pershing's 1st Army Corps, 321st Infantry Division. He was in the Meuse-Argonne offensive, St. Die, France and received a Victory Medal. (BRN.)

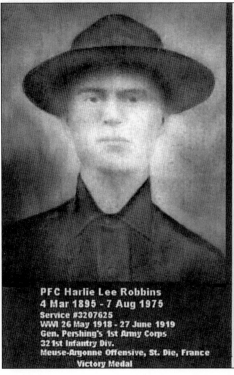

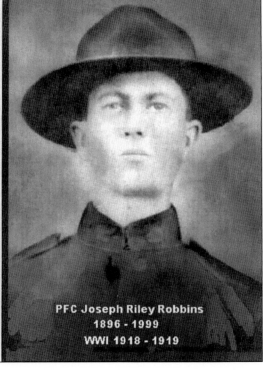

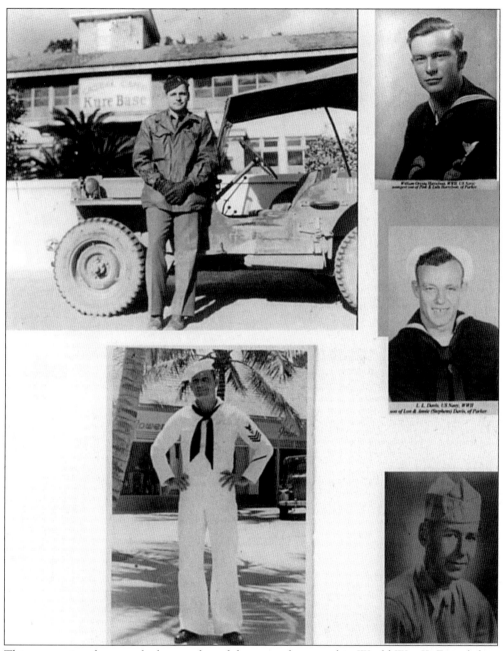

This composite photograph shows a few of the men who served in World War II. From left to right at the bottom are Noah D. (Red) Anderson, United States Navy and son of George and Palestine Anderson and brother of Bernice Pratt; Roy L. Houpt Jr., United States Army; (middle) William Oresta Harrelson, United States Navy; (top left) Lt. Elmer Kenneth Parker; and L.L. Davis, United States Navy. (AC, BRN, and EKP.)

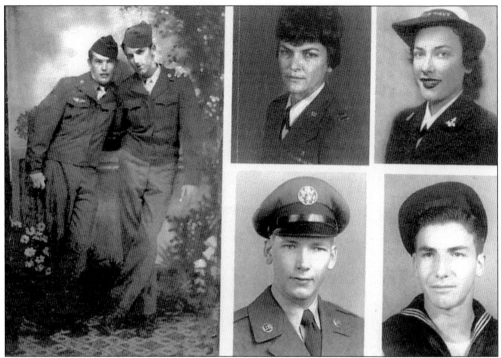

Shown here, from left to right, are Henry Vickers, Billy Pennington, Horton Pennington, Henry Douglas Pennington, Donna Pennington, and Argie Pennington. (LRPG.)

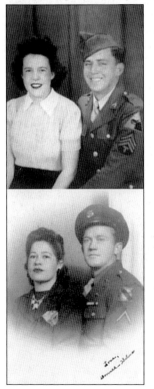

These two Pratt cousins in the Army are shown with their wives. At top are Harold and Lillian Ligon Pratt and at bottom are Donald and Thelma Story Pratt. Donald was stationed on a minesweeper out of Boston harbor and Thelma worked in defense plants there during the war. (AWA and Thelma Pratt.)

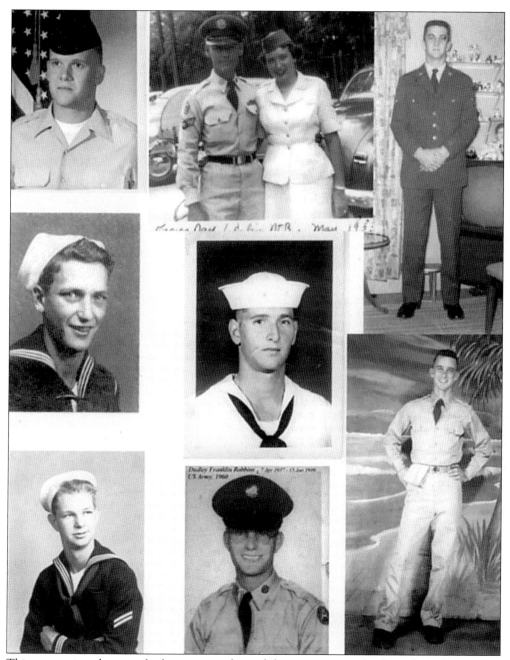

This composite photograph shows a sampling of the servicemen who have served in various eras. From the top, from left to right are Gary Parker, Bert Vineyard, Phyllis Smith (later Vineyard), and Stuart Arthur Pratt Jr; in the middle are Gordon Pennington and Kenny Parker; and at the bottom are Joe Robbins, Dudley Robbins, and Joe Swearingen. (EKP, PSV, JWS, and AC.)

During World War II, family reunions were bittersweet. Lusty, Ellen, and Elmer Kenneth Parker are shown here. (EKP.)

Noah D. (Red) Anderson, on furlough during World War II, visits with his four sisters at the Stuart Pratt home. They are, from left to right, Margaret, Bernice, Grace, and Joyce. (AC.)

Nine

COOPERATION AND INCORPORATION

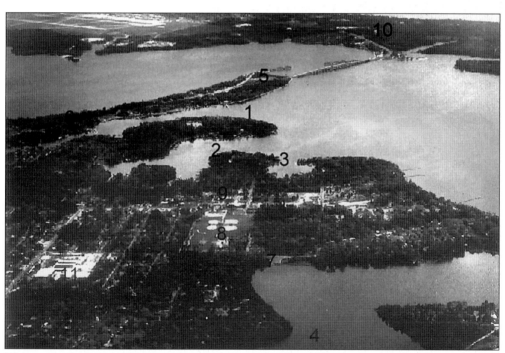

This is an aerial view of Parker, showing how it is embraced by the bay and bayous. Located at (1) is Pitts Bayou, (2) Parker Bayou, (3) Pratt Bayou, and (4) Martin Bayou (now Lake). Parker is a small city but it has five municipal parks, including (5) Earl Gilbert Park, (6) Under the Oaks Park, (7) Parker Environmental (PEEP) Park, (8) the sports park and walking track, and (9) Heritage Park. The City Hall complex, fire, and police departments are located between (8) and (9). Parker School is (11) and Tyndall AFB is across the bay (10).

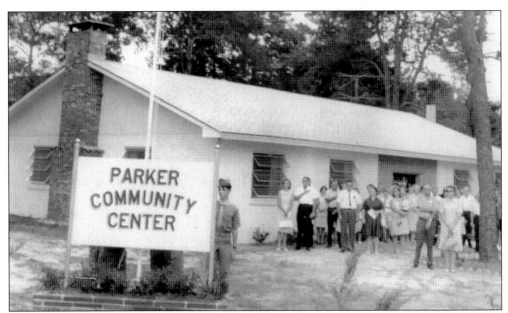

This photograph was made at the dedication of the Community Center on Saturday, August 12, 1967. The Parker Boy Scouts are conducting the flag ceremony. The Parker Men's Club was formed in 1948 with 105 members, who worked to improve the community, established a volunteer fire department, and began to plan for incorporation. The Men's Club and the volunteer firemen built the Parker Community Center building with all volunteer labor. (LRPG.)

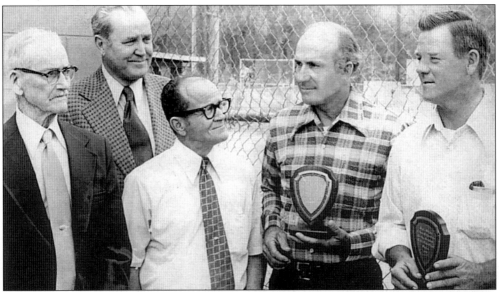

From left to right Henry Pennington, Mayor Earl Gilbert, and Councilman Jessie Merchant present plaques to Henry Douglas Pennington and Gayle Hartzog. This photo appeared in the *News Herald* on March 23, 1974. The caption states that Henry Pennington and Hartzog received a plaque for improving the baseball and softball complex. Henry David Pennington was recognized for service to the community in many areas. The complex was renamed Pennington Field.(LRPG.)

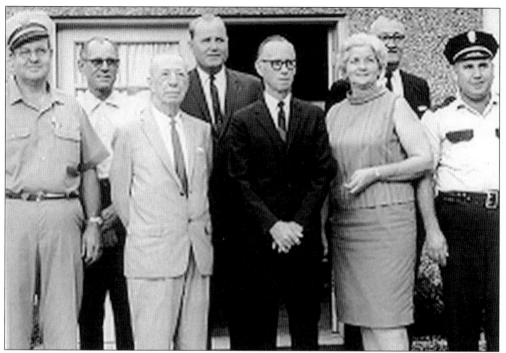

The first mayor and council of the new City of Parker are shown here. From left to right are fire chief Roy Roberts, councilman Cliff Fleming, councilman Irving Myers, mayor Earl Gilbert, councilman Jack Askew, city clerk Joyce Robertson, councilman Aubrey Dykes, and police chief Joe Walker. (Courtesy of the City of Parker.)

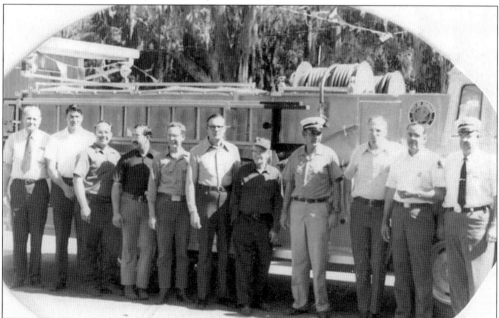

This photograph was made at Firemen's Appreciation Day on Sunday, April 21, 1974. Shown left to right are Earl Gilbert, Aubrey Dykes, two unidentified, Gerald Noel, Dan Shores, Harvey Pratt, Bud Davis, Gerald Suber, Carl Steelman, and chief Roy Roberts. (EDR.)

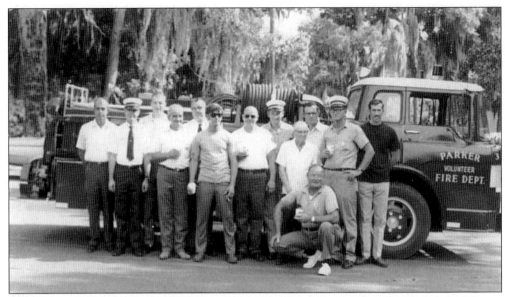

The Volunteer Fie Department is pictured with one of the trucks it built. From left to right are Charles Holley, two unidentified, R.L. Spann, Roy Roberts, two unidentified, Bud Davis, Harvey Pratt, Dan Shores, Carthell Hightower, unidentified, and Ed Hargrove in front. (EDR.)

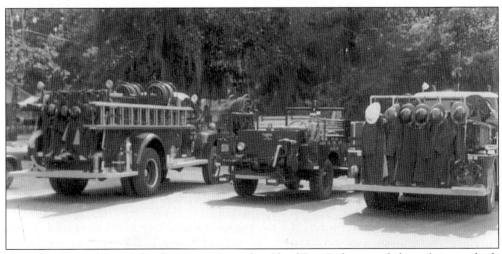

Shown here are three of the department's trucks. Chief Roy Roberts and the volunteers built many trucks themselves, for Parker and other communities. (EDR.)

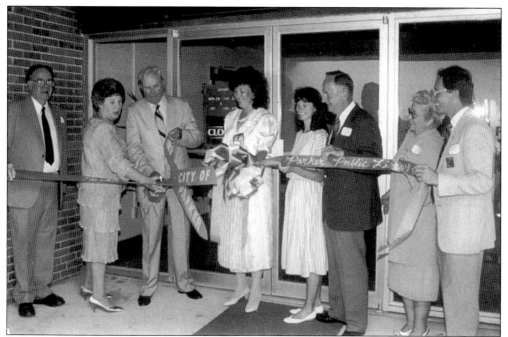

This photograph was made at the grand opening of the Parker Public Library, a branch of the Bay County Public Library in 1988. From left to right are councilman John Boisky, councilwoman Alpharetta Holbrook, mayor Earl Gilbert, councilwoman Brenda Hendricks, unidentified, councilman John Forehand, Rosemary Cotton, and library director George Vickery. (Courtesy of City of Parker.)

Parker Public Library is to the left, and the Community Center is to the right. Behind them are the city hall and the police and fire departments. Upon Earl Gilbert's retirement, Brenda Hendricks was elected mayor. She has continued improvements to the city and several parks have been established. Only around the shores of the bayou can you sense the fishing village of the 1800s. Along Highway 98 and the Tyndall Parkway there are banks, supermarkets, and restaurants.

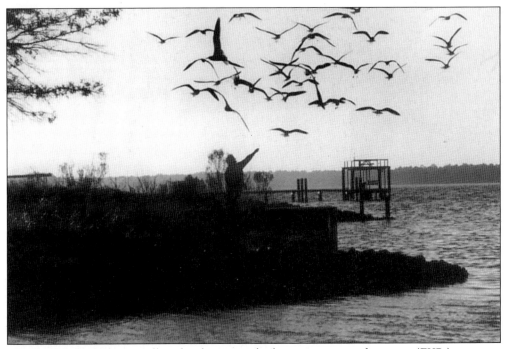

Mary Parker feeds the seagulls at her home on the bay on a serene afternoon. (EKP.)

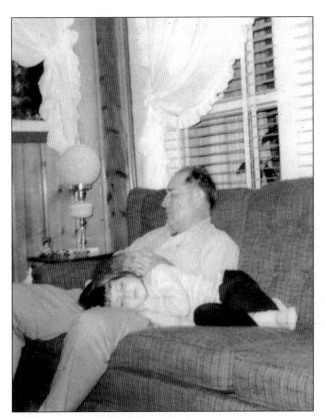

A little naptime is necessary, according to Grandpa Pratt and Melissa Ann Houpt in this December 1966 photo. (AC.)